IMAGES
of America

LOS ALAMOS
AND THE PAJARITO PLATEAU

The Jemez Mountains have always been a main character in the story that is Los Alamos. Their resources nurtured Native Americans and, later, offered a wilderness setting for the Los Alamos Ranch School. Their scenic beauty and outdoor recreation boosted morale during the Manhattan Project, and today, those same forests and trails beckon an environmentally aware and health-conscious population on the Pajarito Plateau. (Courtesy of Los Alamos Historical Museum Archives.)

ON THE COVER: Los Alamos Ranch School boys gather around a fireplace in Fuller Lodge, waiting for the dining room to open. Fuller Lodge would become a gathering place for scientists during the Manhattan Project and, later, for the town of Los Alamos. It has been looked upon as the center of all three communities in their time, holding an honored place throughout a diverse history. (Courtesy of Los Alamos Historical Museum Archives.)

IMAGES
of America

LOS ALAMOS
AND THE PAJARITO PLATEAU

Sharon Snyder, Toni Michnovicz Gibson,
and the Los Alamos Historical Society

ARCADIA
PUBLISHING

Published by Arcadia Publishing
Charleston, South Carolina

Printed in the United States of America

Library of Congress Control Number: 2011924548

For all general information, please contact Arcadia Publishing:
Telephone 843-853-2070
Fax 843-853-0044
E-mail sales@arcadiapublishing.com
For customer service and orders:
Toll-Free 1-888-313-2665

Visit us on the Internet at www.arcadiapublishing.com

*To Rebecca Collinsworth, archivist, Los Alamos Historical Museum,
and Dan Comstock, photo archivist, Los Alamos National Laboratory*

CONTENTS

ACKNOWLEDGMENTS

We have many people to thank for helping to make this book possible. Our first contact was the Los Alamos Historical Society, who agreed to partner with us, and for that, we are very grateful. Los Alamos Historical Museum archivist Rebecca Collinsworth provided exceptional service in the midst of a frozen pipe flooding disaster. To search further, we met with Los Alamos National Laboratory photo archivist Dan Comstock, who patiently sat with us as we examined negatives and prints, and every time we changed our minds and needed another image, he was cheerful and prompt and generous. Also at Los Alamos National Laboratory were Alan Carr, Fred de Sousa, and Ellen McGehee, who provided photographs and information. We are grateful, also, for specific images that came from the following dedicated Los Alamos residents: Heather McClenahan, Larry Campbell, and Ron and Corine Christman. For the many who answered our constant questions—Dorothy Hoard, Georgia Strickfaden, Lou Pierotti, Bun Ryan, Ted Church, and the staff at Mesa Public Library—we could not have done this without you. And to the friends and family we neglected while working on this book, your support and love meant a lot. Especially, thank you, John!

Unless otherwise noted, all images are courtesy of the Los Alamos Historical Museum Archives.

INTRODUCTION

Los Alamos, New Mexico, a modern town today, has a history as varied and colorful as the layers of volcanic tuff and basalt on which it lies. The town sits atop the Pajarito Plateau, a series of narrow mesas and canyons that jut eastward toward the Rio Grande with the Jemez Mountains as their western backdrop. The story of Los Alamos combines natural and atomic explosions, Native Americans and Spanish explorers, ranchers and homesteaders, archaeologists, teachers, scientists, and environmentalists, blended in a community that has made and preserved history.

The Pajarito Plateau originated from massive volcanic explosions that formed mountains on the plateau's western edge, while time and erosion shaped the fingers of the mesas and canyons to the east. This ages-old volcanic ring of mountains is distinct in an aerial view, and a drive along State Highway 4 reveals a display of the caldera that has become a series of huge valleys.

Though much evidence remains of Native American settlements on the mesas and in the canyons, dating from the 9th to 13th centuries, the rugged terrain kept the area isolated and sparsely inhabited. In the late 1800s, descendants of Spanish explorers filed claims under the Homestead Act, and farms could be seen atop the mesas. Archaeologist Edgar L. Hewett excavated in the area and proposed the name *Pajarito*, which is Spanish for "little bird," an inspiration that came from the name of a Tewa Indian ruin nearby. Newcomers, like lumberman Henry Buckman from Oregon, came to the plateau, and a narrow gauge railroad line followed. However, the elevation of the plateau at approximately 7,000 feet and the rocky, steep canyons made travel difficult, so the population remained low.

In 1908, it was agronomist Harold H. Brook, of Illinois, who established a farming and ranching operation on the mesa that first used the name *Los Alamos*, "the cottonwoods." In 1917, Brook sold the claim to Ashley Pond Jr., whose dream was not to ranch but to establish a school of health and outdoorsmanship for boys. The Los Alamos Ranch School became a reality, and permanent buildings, some designed by famed architect John Gaw Meem, took shape.

Forest ranger A.J. Connell assumed director's responsibilities, and with the magnificent Pajarito Plateau as its setting, the Los Alamos Ranch School attracted students from as far away as the East and West Coasts. As an outdoor classroom, the school balanced studies with calisthenics, horseback riding, and long pack trips. During its 25 years of existence, the school's student roster included many notable men. Among them were Wilson Hurley, artist; Rogers Scudder, author of classical language textbooks; John Crosby, founder of the Santa Fe Opera; Whitney Ashbridge, lieutenant colonel and post commander of the Manhattan Project; John Reed, president of the Santa Fe Railway; Sterling Colgate, physicist at the Los Alamos National Laboratory; and Bill Veeck, owner of the Chicago White Sox, to name only a few of the many "LARS men" who made significant contributions to the nation and their communities.

When the Army announced that the Los Alamos Ranch School property was being condemned and acquired for military purposes, an era ended unexpectedly. Beginning in 1943, a secretive trail of scientists, their families, support staff, military men and women, and supplies made their

way up the mountain to the Los Alamos Ranch School site. A community sprouted with cryptic names like P.O. Box 1663, Project Y, and the Hill, a nickname that remains today. The isolation was a necessity, but when history was made on August 6, 1945, with the bombing of Hiroshima, the Manhattan Project secret was revealed.

The explosive growth of the town, which was often an issue during its secret years, was only one problem that faced the military and scientific community at war's end. Later that year, as the Army-Navy "E" Award was presented to the Manhattan Project, the beauty of a sunny October day and a decorated Fuller Lodge belied the unanswered questions about the future of Los Alamos. In just less than three years, an isolated plateau with a few hundred residents had become a town of 5,700 people with a weapon that had changed the world, yet the future of the project remained unclear.

Dr. Norris Bradbury stepped in, and under his leadership, the atomic bomb project became the Los Alamos Scientific Laboratory. Permanent housing replaced temporary military units. Los Alamos became a county rather than P.O. Box 1663, and the nuclear research expanded to include peacetime uses of atomic energy. These were Cold War days, and the entire town of Los Alamos had an evacuation plan. Every Friday afternoon at 5 p.m., the residents were reminded of what the civil defense siren sounded like.

Today, the laboratory focuses on national security as well as health, environmental, and energy research, and in the post–Cold War, 21st century, a restructured Los Alamos National Laboratory operates with more than 10,000 employees under the US Department of Energy. Yet, there are other foci for the town. In 2000, the devastating Cerro Grande fire in the Jemez Mountains burned into Los Alamos and left more than 400 families homeless, sparking a new conversation in environmental protection. Recreational opportunities abound, including skiing on Pajarito Mountain and hiking in the newly protected Valles Caldera National Preserve. Historians, archivists, and residents work diligently to preserve the past. Their efforts have recently restored a homestead cabin and secured the original ranch school home that Robert Oppenheimer occupied during the Manhattan Project era.

A drive to the Hill on Highway 502 affords a stunning and expansive view of the mesas and canyons that make up the Pajarito Plateau. A hike in the area provides a view of the past with the likes of Bandelier National Monument and Puyé Cliffs. The town embodies the natural beauty, the artifacts of the past, and the scientific future. This collection of photographs from the Los Alamos Historical Museum Archives, the Los Alamos National Laboratory, the Michnovicz-Gibson collection, and the private collections of other historians tells the story in its many layers and historical settings and brings the rich history of Los Alamos to life.

One

EARLY DAYS OF THE PAJARITO PLATEAU

The Jemez Mountains of northern New Mexico have provided the backdrop for some of the world's most dynamic history. Volcanic eruptions, mountain building, and erosion worked their magic to create an isolated region of scenic beauty that attracted a pageant of diversity.

The first inhabitants were Native Americans who peopled the Pajarito Plateau on the eastern side of the Jemez range, leaving stone tools and a network of trails from their earliest days. For millennia, Paleo-Indian hunters and gatherers entered the area, but it was not until the 12th century that small farmsteads appeared. By 1350, small groups had banded together to build pueblos that now lie in ruins at such places as Tsankawi, Tsirege, Puyé, and Tyuonyi. Ultimately, they moved their homes to lower elevations in the Rio Grande Valley to find more reliable water and longer growing seasons. There, they established Santa Clara, San Ildefonso, Pojoaque, Nambé, Tesuque, and other nearby pueblos.

With the coming of Spanish explorers in the 1500s, land grants were established, placing boundaries on the plateau for the first time. In the late 1800s, enterprising men, like Frank Bond and Henry Buckman, discovered high meadows for grazing and abundant timber for sawmills, but their occupation of the region was transitory. They were followed by pioneers seeking something more permanent. Homesteaders applied for patents, built cabins, and planted summer fields, while a few ranchers bought larger tracts of land. Archaeologists discovered the rich possibilities for study of ancient cultures, and Edgar L. Hewett boldly envisioned a Cliff Cities National Park. In 1914, Detroit investors followed the dream of Ashley Pond Jr. in backing an elite hunting and fishing retreat known as "the Pajarito Club." None of these ventures survived, but remnants of the decades and the spirit of the pioneers live on today as a strong connection to the plateau's past.

The Valle Grande is one of several *valles* or valleys that make up the caldera in the Jemez Mountains. Through the years, the area has been a hunting ground and obsidian quarry for Paleo-Indians, a land grant called the Baca Location, a summer pasture for sheep, and an exclusive cattle ranch. In 2000, the much-loved formation became the Valles Caldera National Preserve.

Ancestral Puebloans occupied cliff dwellings or *cavates*, along with Tyuonyi Pueblo, in Frijoles Canyon until the mid-1500s. These ruins became part of Bandelier National Monument in 1916, named for anthropologist Adolph Bandelier who first visited the area in 1880.

Visitors marvel at the Long House ruins in Bandelier National Monument in 1916. Archaeologist Edgar L. Hewett had hoped to turn Pajarito Plateau ruins, like Long House, into a much larger Cliff Cities National Park, but there were already too many people on the plateau with conflicting interests.

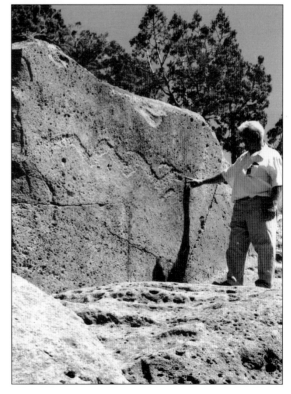

Charlie Steen, archaeologist for the Los Alamos Scientific Laboratory, examines a seven-foot-long petroglyph of the Awanyu in Pajarito Canyon. In Pueblo beliefs, the Plumed Serpent is a deity associated with rain and running water, the necessities of life. This Awanyu points the way to the ruins of Tsirege Pueblo on the mesa above.

A shepherd waters his sheep at the Rio Grande, near Buckman, around 1915. Herds like this one were driven to high pastures in the Jemez Mountains for the summer.

Lumbering operations were lucrative around the turn of the last century. Owned by men like Henry Buckman and T.J. Sawyer, these transient mills prepared lumber and railroad ties for transportation by wagon to the rail siding called Buckman.

In the late 1880s, Buckman Set was erected in the Jemez Mountains. This building most likely functioned as a bunkhouse for workers who cut timber and milled lumber for shipment on the Denver & Rio Grande Railway that made stops at Buckman, which was a collection of rudimentary wooden buildings, including a post office, on the east side of the Rio Grande.

Ashley Pond Jr. sits at the wheel of his Hudson touring car on the Buckman Bridge around 1914, the same year he opened the Pajarito Club. According to Pond's daughter, author and poet Peggy Pond Church, the bridge pictured here was the third one to occupy this site. The first two had washed away.

The Denver & Rio Grande Railway, later called the Denver & Rio Grande Western Railroad, crossed a trestle just south of Otowi, seen here around 1905. In early days, cars sometimes straddled the narrow gauge tracks to cross the trestle as well, with their drivers hoping the train schedule had not changed!

Harold H. Brook, an agricultural college graduate, came to the plateau in 1907, took a partner in William "Mac" Hopper, and established Los Alamos Ranch, located where Fuller Lodge and Ashley Pond exist today. Unlike his neighbors, Brook used modern machinery and methods to produce cash crops.

Homesteaders and two wagons loaded with supplies make the trip to the plateau in the spring of 1938. Most of the Hispanic farmers worked their homesteads only in the growing season, returning to the valley for children to attend school in the winter months.

Victor Romero filed homestead papers in 1916 for land that his family already occupied in their one-room cabin with two windows. In 1934, Romero and his relatives built a larger cabin for his wife, Refugio, and their six children. Seen here at its original location, the Romero Cabin now stands on a site near Fuller Lodge in the Los Alamos Historic District and is fully restored.

This photograph of the Martin Lujan homestead on North Mesa was taken in December 1942, just days before the government condemned the homesteads and ranches of the plateau for the Manhattan Project takeover. Martin Lujan's grandson Manuel Lujan Jr. served as a US congressman from New Mexico for 20 years and was secretary of the interior from 1989 to 1993.

In 1899, William White filed for this homestead of 160 acres in the northern part of present-day Western Area. He sold it to Mac Hopper in 1908, but in later years, White's sons Ben and George worked for the Los Alamos Ranch School as foreman and dairyman. George's son Andrew attended the ranch school from 1923 to 1927.

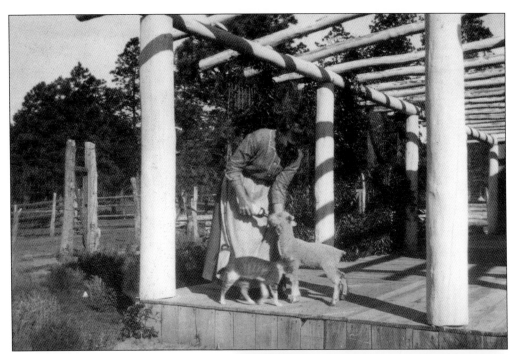

Mattie Brook was 52 years old when she was awarded a homestead patent in 1914. Her son Harold eventually bought Mattie's land, Mac Hopper's holdings, and the neighboring homestead of Benigno Quintana to own most of Los Alamos Mesa. In 2000, a Los Alamos hiking path was named the Mattie Brook Trail.

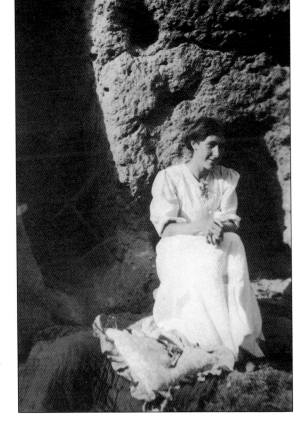

Wives of the homesteaders had to be strong enough to match the rigors of life on the plateau as well as the men. Cassy Brook once took a dare from her husband, Harold, to spend the night in a cave, and as the picture shows, she took along her pistol, just in case!

Ted and Rosa Grant Mather had a cabin in Water Canyon, though they were not allowed a homestead patent because the cabin was not on farmland. Ted eventually became the wrangler for the Los Alamos Ranch School, and he and Rosa moved from their cabin to the school.

In addition to experimenting with high altitude farming and raising crops, Harold Brook established a sawmill on his land. The operation was near his hay barn, also seen in this c. 1915 photograph.

To promote a revival of San Ildefonso pottery, Madame Vera von Blumenthal and Rose Dougan built a home and artist workshop near Tsankawi in 1918. Their work with the artisans led to the refinement of the pottery associated with the pueblo today. Von Blumenthal was reportedly descended from Russian royalty. Thus, the ruins of their adobe home are known as "Duchess Castle."

In 1918, members of a New Jersey family purchased Anchor Ranch for their handicapped son. Alex Ross, a young man of 23, moved to the Pajarito Plateau with caretakers Connie and Francis Smithwick and their sons. The Smithwicks turned the property into a small working ranch before moving to Southern California for health reasons in 1935. Alex eventually moved to another ranch near Silver City.

A.J. Abbott was a retired judge in his mid-60s and his wife, Ida, was 52 when the pair decided to start a farm and guest ranch in Frijoles Canyon in 1907. On their first visit to the canyon, they spent the night in the rooms of a 400-year-old cliff house. Ida recorded the following in her journal: "I never slept sounder in my life."

Ten Elders Ranch was built in Frijoles Canyon just west of the Tyuonyi ruin, as seen in this photograph. "What a delightful summer resort this canyon would make," Ida Abbott observed the first time she saw it. She and her husband, Judge A.J. Abbott, made it into exactly that, farming and catering to visitors for almost a decade. The land became Bandelier National Monument in 1916.

In 1914, Ashley Pond Jr. and four Detroit investors bought the 32,000-acre Ramon Vigil Land Grant and turned it into an elite hunting and fishing club. With the headquarters centered in Pajarito Canyon, the men named their venture the Pajarito Club. From left to right are the guest house, the Pond family home, and the club office, now known as "the Pond Cabin."

This vintage Hudson touring car, dubbed "Ashley's Limousine," shuttled visitors back and forth from Santa Fe to the Pajarito Club over challenging dirt roads. Pond often recited the following poetic variation, "Jiggle, jiggle little car, how I wonder where we are. From the roughness of the way, I should think near Santa Fe."

Ashley Pond Jr. built this log cabin as an office for the Pajarito Club in 1914. In front of the cabin are, from left to right, Pond's wife, Hazel, daughter Dottie, business manager Captain Pearsall, Pearsall's mother, governess Ellen Purdue, and Pond, seated on the ground. Today, the Pond Cabin is listed in the New Mexico State Register of Cultural Properties. It is scheduled for restoration and will be an important structure for the proposed Manhattan Project National Historical Park.

The Pond Cabin held the office from which Ashley Pond Jr. ran the Pajarito Club for its two years of its existence, 1914–1916. Only two of Pond's absent Detroit partners ever visited the club in which they had invested.

The Pond family home had been the commissary for a sawmill before it was renovated for the Pajarito Club, but a Santa Fe architect turned the building into a comfortable residence. The first time Hazel Pond saw her future home in 1914, the door was hanging by one hinge and there was a cow standing in the living room!

Ashley and Hazel Pond find a rare moment to reflect on the beauty of their canyon in this image from around 1915. Running the Pajarito Club and tending to the needs of visitors left little time for themselves or for family.

Possibly one of the last mountain lions killed in Pajarito Canyon poses involuntarily with, from left to right, wrangler C.B. Ruggles, Peggy Pond, Hazel Pond, Laddie Pond, Cassy Brook, Frank Brown, Theiline McGee, Felipe Lechero, Dottie Pond, and Ashley Pond Jr.

In the summers, the Pond children roamed Pajarito Canyon, rode horses, and explored cliff dwellings in their own personal paradise. Young Ashley, known then as Laddie, and his sister Dottie are seen here beside a cliff dwelling around 1915. With their older sister Peggy, they collected arrowheads and roasted apples over fires built in the ruins.

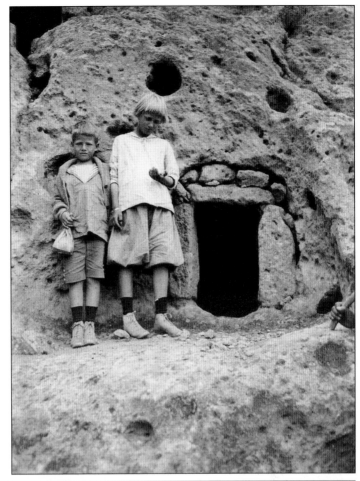

The Pajarito Club entertained many visitors, among them the Templeton Johnson family from San Diego, founders of the progressive Francis Parker School in that city. Sons Delafield and Winthrop Johnson loved their time in the canyon, and Winthrop returned to attend Ashley Pond's Los Alamos Ranch School, graduating in 1927.

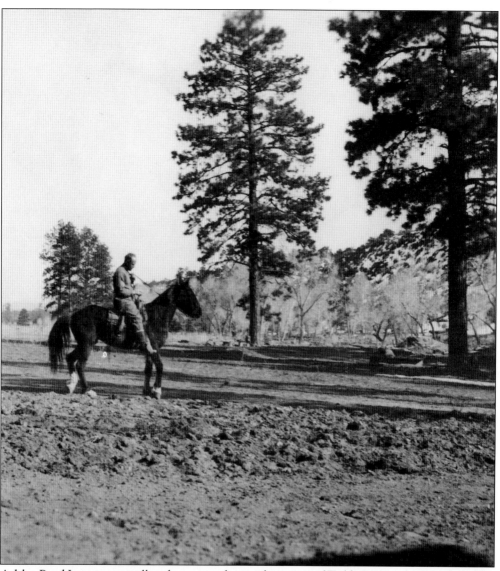

Ashley Pond Jr. was an excellent horseman, having been one of Teddy Roosevelt's Rough Riders. He loved the outdoors, in particular the Pajarito Plateau, and when the Pajarito Club failed, he looked for another way to remain on the plateau. He became partners with Harold Brook and ultimately bought Brook's Los Alamos Ranch, where he resurrected a dream of starting a ranch school for boys. It was the second time Pond had attempted to found a school, and this time, he would succeed.

Two

THE LOS ALAMOS RANCH SCHOOL

Ashley Pond Jr. was a dreamer. He went from one dream to another. Some failed, but on the other hand, some succeeded beyond his wildest expectations. In 1917, Pond bought out his neighbor Harold Brook and opened the Los Alamos Ranch School on the Pajarito Plateau. He built a central structure known as "the Big House" and made use of other buildings on the former Brook homestead. Then, realizing that he was not an administrator, he hired a forest ranger named A.J. Connell to run his school. Connell was the right man for the job. He staffed the school with talented, dedicated teachers and local workers who remained loyal to Connell and his principles. He created a campus of log-and-stone buildings surrounded by vast lawns and gardens and designed a program that taught young men to be not only strong and educated but of good character.

For a short span of time, the Los Alamos Ranch School was a shining light in the history of New Mexico, but life's most obvious lessons are that nothing lasts forever and that change is inevitable. In late 1942, the US government took over the Pajarito Plateau, condemning the school as well as homesteads and ranches to locate a top-secret weapons project in the plateau's isolation.

The school may have lasted for only a quarter-of-a-century, but for most of the boys who went there, Connell and Pond's dream gave them the time of their lives.

A.J. Connell followed his older brother to New Mexico from New York. In 1917, he was working as a forest ranger near Bland when Ashley Pond hired him to run the newly formed Los Alamos Ranch School, proposed as a progressive health school emphasizing vigorous activity. Having fought respiratory ailments as a boy, Pond wanted an outdoor school where sickly boys could develop robust health in high mountain air. Connell had also been a Boy Scout leader, so believing in the standards of that organization, he designed a program along the lines of Scout discipline. After a year, however, he recognized the need for something more. The school needed an academic program, and to that end, Connell recruited a young Yale graduate named Fayette Curtis to become the school's first headmaster and teach all subjects. From that modest beginning, the ranch school developed into a respected prep school that sent its graduates to some of the finest universities in the country. Connell was the only director in the 25-year history of the school.

The students, many of them from Eastern cities, were delighted to explore the different environment of New Mexico. The forests and canyons of the Jemez Mountains offered exciting possibilities, such as climbing in and out of cliff dwellings carved into soft volcanic rock. Structures similar to those shown could be encountered in almost any canyon near the school, along with early trails and petroglyphs.

The Los Alamos Ranch School students and masters of 1921–1922 are, from left to right, (first row) Fayette Curtis (headmaster), Edward Nicholas, Walter Hoffman, Lancelot Pelly, Joe Bleakie, William Mayo, Tom Borton, and Fermor Church (master); (second row) Philip Clay, John Bleakie, George Henry, Malcolm Bigelow, Ashley Pond, and Sid Kieselhorst; (third row) director A. J. Connell, Earl Kieselhorst, Ted Bremer, Joseph Dahlgren, Alfred Hill, Robert Lewis, George May, William Regnery, and Lawrence Hitchcock (master).

Spectators watch a basketball game against the Santa Fe Boys School in front of the Big House. Sports at the ranch school were relatively informal and varied from year to year, depending on the interests of the boys enrolled. Archery, boxing, polo, and fencing were all popular at times, but the school was most successful in tennis, winning the state championship several times.

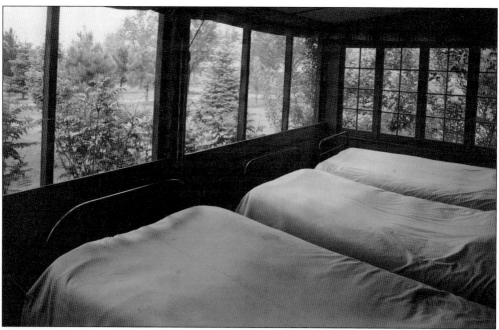

While the image of a health school was put aside after its first year, the ranch school viewed the health of the boys as a prime concern throughout its existence. With progressive health goals in mind, the boys slept on sleeping porches, exposed to fresh air year-round.

A great stone hearth that was open on all four sides dominated the first floor of the Big House. A master read adventure stories to the boys in front of the fire each evening. A library, dining area, study tables, games, and a Victrola rounded out the room. Student rooms, masters' quarters, classrooms, offices, and the infirmary filled the remaining space in the three-story building.

Students had regularly scheduled hours when they were assigned service chores necessary to keep the school functioning well. During this community work, the boys maintained the grounds, cared for the horses, worked in the library, gardened, and built trails or recreation facilities, such as this toboggan slide for winter fun.

George May III attended the summer camp in 1919 and enrolled in the autumn to spend four years at Los Alamos Ranch School, graduating in 1923. His parents, George and Edith, presented the school with funds to build an alpine cabin for the boys. The cabin, high in the Jemez Mountains, was named Camp May.

The Camp May cabin, built in 1923 on land leased from the US Forest Service, was used as a base camp for weekend outings, such as skiing and hunting trips, for the older boys. It became an important part of the outdoor life of the school. Ranch school master Fermor Church took his bride, Peggy Pond, to Camp May for their honeymoon.

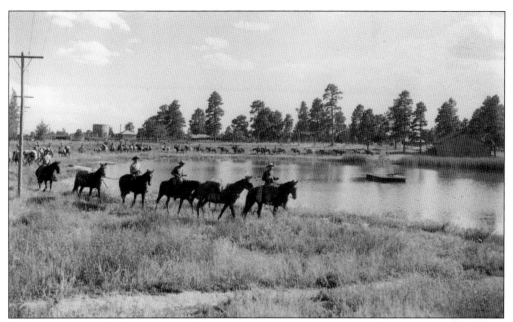

Eager boys on horseback ring Ashley Pond as they leave for a pack trip in the high country. William Mills, a 1922–1923 master who was fond of puns, could not resist changing the name of the body of water previously called the Duck Pond. Thereafter, it became Ashley Pond, a humorous but fond honoring of the school's founder.

Edward Fuller joined the staff of the ranch school in a non-teaching capacity in 1917 when, with his family's help, he gave financial backing to the fledgling school. Partially paralyzed from polio, he enjoyed a more active life in the mountains than he had previously experienced in Detroit, but he died of an illness in 1923.

The father of Sam Hamilton, class of 1926, presented the school with funds to purchase and renovate a small cabin in Pueblo Canyon east of the school. Appropriately named Camp Hamilton, the cabin was used often for outings with the younger boys who were not as proficient at horseback riding as the older students.

In the early years of the school, commencement was held in Graduation Canyon, located east of the campus. The ceremony was unique, with the graduates entering on horses, parents and guests seated on boulders, and refreshments served in pottery bowls by San Ildefonso Indians in native dress.

The Denver & Rio Grande Railway train, dubbed "the Chili Line," made twice-weekly stops at Otowi to unload freight for the ranch school. The freight was stored in a boxcar beside the tracks until the school truck could transport it up the precarious dirt road to the school.

Otowi Bridge, across the Rio Grande, was a familiar sight to the ranch school boys, as was Edith Warner's house beside the Chili Line tracks. Edith Warner was hired in 1922 to guard the arriving freight until the school could collect it. She and her Indian helpmate Tilano were memorable to anyone who stopped at the bridge.

Fuller Lodge has been the centerpiece of Los Alamos since it was built in 1929, designed by famed Santa Fe architect John Gaw Meem. It held the school's main dining room, a kitchen, masters' quarters, and the rooms of director A.J. Connell. The lodge was named for Edward P. Fuller, a young staff member who died in 1923.

In years when the ice depth on Ashley Pond reached a foot or more, large blocks of ice were cut and transported to an icehouse on the south side of the pond. There, it was packed in sawdust for insulation. The icehouse could store enough ice for a two-year supply.

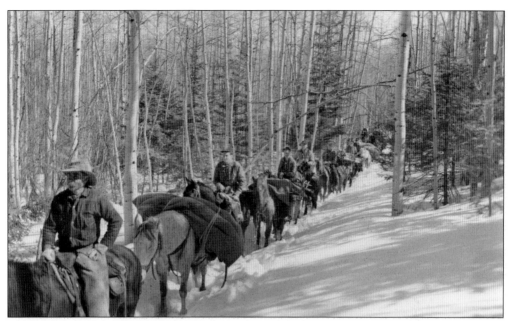

Wrangler Ted Mather leads a winter pack trip through high country aspens. Mather was a favorite with the boys, sharing his knowledge of horses and telling old West tales, including how he got the scar on his leg from an Apache arrow. He always wore a holstered pistol and colored his large mustache with lampblack.

Both Ashley Pond and the smaller Douglas Pond in Los Alamos Canyon were used for hockey when winter weather permitted. Douglas Pond was located where consistent shade prolonged better ice.

The Los Alamos masters were well prepared to teach their subjects, but the real academic advantage at the ranch school was the small class size, some with one-on-one instruction. Each student had a course plan based on background course work, entry test scores, and goals, and he could advance as rapidly as he mastered a subject.

A.J. Connell believed in the health values of a proper diet. School meals were scientifically planned, whether eaten in the Fuller Lodge dining room or on a pack trip. The ranch grew much of its own food, and other fresh items were shipped from Santa Fe. Local dishes like *atolé* were also included on the menu. Boys did not have the option of refusing any food they were served at meals.

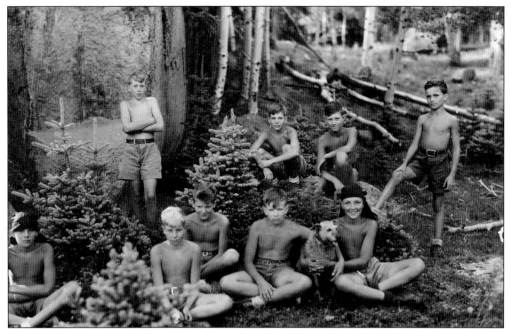

The Los Alamos Ranch School was registered as Boy Scout Troop No. 22 in October 1918, and A.J. Connell used a variation of Scout patrols to organize the boys by physical size and maturity. This is Piñon Patrol, and with increasing maturity, students were placed in Juniper, Fir, and Spruce patrols.

A summer camp was offered to boys almost every year, and the highlight was the long camp. The pack trip took more than two weeks, and the favored destination was the San Pedro Peaks and the Highline Trail, 50 miles through mountains and open meadows with stops at several campsites. The view from 10,523-foot San Pedro Peaks seems worth the ride.

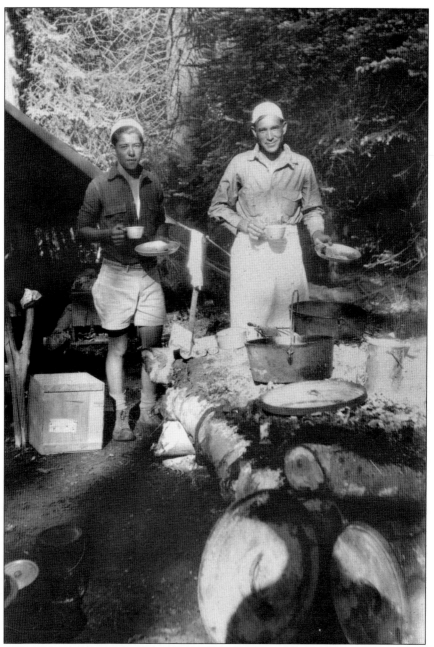

Bences Gonzales worked for the Los Alamos Ranch School for 23 years until the Manhattan Project takeover. He ran the trading post, was the unofficial postmaster, and accompanied the boys on their long trail rides as camp cook. Perhaps best known for his famous sopapillas cooked in a Dutch oven over the campfire, Gonzales was a bright star in a constellation of many at the ranch school. He will long be remembered, as seen here (right) in his white apron and cap, for being the wise and gentle man that he was. His helper on this trip was his brother-in-law Ernesto Romero. Gonzales and Romero were representative of the skills and dedication given by many local families in the area who worked at the ranch school. Their contributions were instrumental in the successful years the school enjoyed.

The Chihuahueños campsite west of Polvadera Peak was also a favorite with the boys. The summer camp drew several graduates to return as camp counselors. Other former students worked in the trading post or corrals for the summer months and, in two cases, taught during the school year.

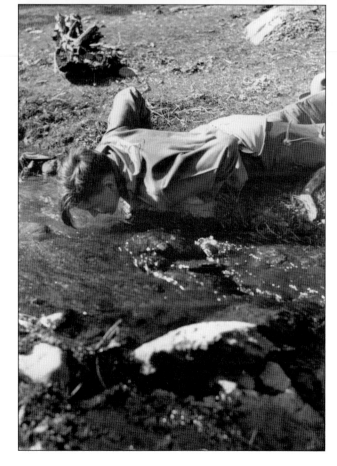

In the words of Fermor Church, the ranch school master, "The eight weeks of the summer season went by all too fast, but in recollection they might often seem the better part of a lifetime."

Members of the Spruce Patrol in 1942 are, from left to right, (first row) David Osborne, Semp Russ, Ben Raskob, Wilson Hurley, and Bob Carter; (second row) Gary Sutcliffe, Charley Butler, Jim Thorpe, and Bee Barr; (third row) Gray Osborne, Peter Wainwright, and Dick Wieboldt. For the young men in this group who graduated in 1942, their thoughts were sobered by the war that would put their life plans on hold.

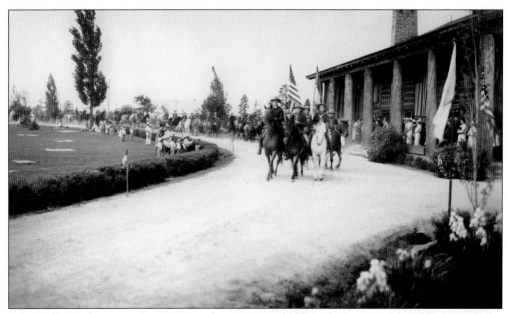

After Fuller Lodge opened in 1929, graduations were held on the east portal and lawn, with the mounted entrance of the student body singing the school song to open the ceremonies. There were Indian dances, mariachis from La Fonda Hotel, and prizes awarded to top students as proud parents looked on.

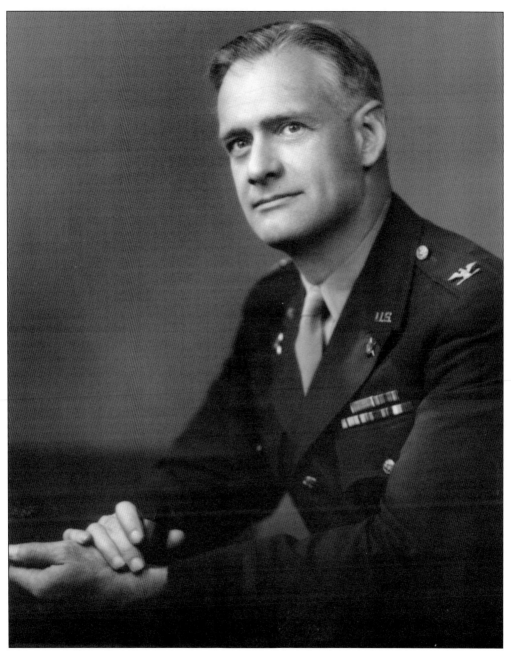

Lawrence Sill Hitchcock came to Los Alamos Ranch School as a master in 1919, fresh out of Yale with Phi Beta Kappa credentials. He was an Army reservist who served briefly at the end of World War I. Eight years later, upon the untimely death of his friend Fayette Curtis, Hitchcock became headmaster. An introspective, scholarly, and serious man, he was described as a balance for A.J. Connell's temperamental and romantic Irish nature, yet the two were great friends with utmost respect for each other. Together, they developed a school that embodied the best of their individual standards and personalities. Hitchcock was called up for service after Pearl Harbor and served as secretary general of the Inter-American Defense Board. He returned on special leave to present Los Alamos Ranch School diplomas to the last graduates on January 23, 1943.

Ted Church (left), pictured with his brother Allen, was one of four young men who graduated in the last ranch school class. He was the son of master Fermor Church and Peggy Pond Church and the grandson of the school's founder, Ashley Pond. Ted went to Harvard and MIT and served in World War II. Allen graduated two years later from the Los Alamos School in Taos.

In April 1942, a military plane flew over the Los Alamos Ranch School, methodically surveying the area. The men aboard viewed a campus of rustic log-and-stone buildings, corrals, lawns, and gardens in a setting of pine forests and mountains. Within months, the school was taken over by the government for a much larger encounter with history.

Three

THE MANHATTAN PROJECT YEARS

War was everywhere, and a hideous regime in Germany was trying to destroy the entire Jewish population. At the same time, European physicists demonstrated that the splitting of the uranium atom could release enormous amounts of energy. The scientists who made this discovery were fleeing the oppression in Europe, and both sides of the Atlantic were beginning to pursue a weapon based on this discovery of fission.

A letter to Pres. Franklin Roosevelt from Albert Einstein catalyzed the government to develop a weapon based on this atom-splitting power, but one challenge was the utter concealment of all research from the outside world. It was October 1942 when a general in the Army and a nuclear physicist set out to find a place where that could happen. J. Robert Oppenheimer, a physics professor at Berkeley, suggested a high plateau in New Mexico to Gen. Leslie Groves. It was remote enough to be secured and it was thought that the existing buildings could be used for scientific staff. Almost immediately, the government condemned the Los Alamos Ranch School and bought it and the surrounding property. They code-named it Project Y of the Manhattan Engineer District. The race to build the world's first atomic bomb was on.

In just months, the town grew to several thousand people who worked and lived in a combination of school facilities and temporary government buildings. No one was allowed in without a pass, mail was censored, and outside travel was restricted. A culture of making do, complaining about the inadequate housing, and being intensely dedicated to the work existed. New names were coined for the place: P.O. Box 1663, the Hill, and, most ironically, Shangri-La. There were trailers, dorms, mud, and six-day workweeks. But none of this stopped the homegrown entertainment. Theater productions and dance bands entertained, movies and beer were 10¢, and for picnickers, the Pajarito Plateau was a recreational dream.

The mission was successful. War ended soon after the second atomic bomb fell on Nagasaki in August 1945, and the world would never be the same.

Everyone assigned to the Manhattan Project made this destination, 109 East Palace Avenue in Santa Fe, his or her first stop. There, Dorothy McKibbin, the "gatekeeper of Los Alamos," made sure everyone had his or her passes, bus ride, and baggage, and she did it with her smile, care, and efficiency. She was hired by Robert Oppenheimer and became his lifelong friend. (Photograph by Bob Martin; courtesy of Toni Michnovicz Gibson.)

When Los Alamos was identified for the atomic bomb project, most travel to the Pajarito Plateau was by small vehicles or horseback on unimproved roads. In 1943, the New Mexico State Highway Department began to tame the westward road for military trucks, construction vehicles, and buses. Switchbacks, like the one in the center of this photograph, were eliminated by cutting through volcanic rock and grading and surfacing the road.

Everyone showed a security pass to military police at this gate. The community was fenced in, and all were required to follow the Security Handbook with warnings such as the following: no visitors, do not establish relations with residents of nearby communities, do not travel outside the Santa Fe area, and do not take any pictures in the post or in the Technical Area.

After entering the town, the trailer section presented itself, often to the horror of newcomers. Private trailer owners paid $5 per month for the space, and government-owned trailers rented for $28 a month, utilities included. Latrines were located between the trailers, prompting one resident to remark, "Sanitary conditions were a disgrace!" (Photograph by John Michnovicz; courtesy of Toni Michnovicz Gibson.)

Original estimates for Project staff of a few hundred were so far off that the housing shortage was continuous. In six months, the Sundt Construction Company built 300 apartments with one, two, or three bedrooms. Interiors included hard wood floors and wood-burning cooking stoves, while exteriors were famous for the oversized chimney stacks, as seen on this one-bedroom duplex. (Photograph by John Michnovicz; courtesy of Toni Michnovicz Gibson.)

As soldiers poured into town, their barracks and mess halls were built. These barracks were located on the west end of Trinity Drive. Mud was everywhere, so the Army plunked down two-by-fours and added gravel and one coat of asphalt to make sidewalks. By 1946, there were 55 barracks housing almost 1,500 people.

The Technical Area almost circled Ashley Pond. Barbed wire and buildings now surrounded the pond that had been used by the ranch school for recreation. Most bomb work was done here although there were 25 satellite test sites on the plateau. Buildings were assigned an English and Greek letter name, like W, X, Gamma, and Sigma. Gamma is the two-story building on the right. (Photograph by John Michnovicz; courtesy of Toni Michnovicz Gibson.)

This water tower stood high enough to become a favorite landmark in a town where buildings were numbered, but streets were not always marked. Water came from reservoirs in Pajarito, Guaje, Water, and Los Alamos canyons. This 250,000-gallon tank provided water pressure and was built adjacent to this ranch school shop building, which soon became the housing office. (Photograph by John Michnovicz; courtesy of Toni Michnovicz Gibson.)

Los Alamos Ranch School cottages were remodeled to accommodate Project leaders, including Gen. Leslie Groves, Ernie Titterton, Kenneth Bainbridge, and Stanislaw Ulam. In the foreground is the Guest Cottage with Spruce Cottage behind it. The ranch school residences had bathtubs, which most apartments did not, so this area was soon nicknamed "Bathtub Row." (Photograph by John Michnovicz; courtesy of Toni Michnovicz Gibson.)

Another ranch school building, the trading post, became a combination store and lunch counter. It was centrally located and popular but quickly outgrew its 900 square feet. Its food concessions were moved to the Service Club, and the trading post became a general store. (Photograph by John Michnovicz; courtesy of Toni Michnovicz Gibson.)

The soldier at the far right is doing butcher duty in the Post Commissary. The Army assigned soldiers to various jobs if civilians were not available. When the commissary opened in March 1943, sales totaled about $700, and one year later, sales exceeded $20,000. Security restrictions prevented residents from having bank accounts in Santa Fe, so the commissary also cashed checks. (Photograph by John Michnovicz; courtesy of Toni Michnovicz Gibson.)

The government operated several eating establishments in Los Alamos during the Manhattan Project, including the dining room pictured here in Fuller Lodge. The meal prices ranged from 75¢ to $1.15. There was more charm and elegance here than in the other clubs, post exchanges, and mess halls that served cafeteria-style. (Photograph by John Michnovicz; courtesy of Toni Michnovicz Gibson.)

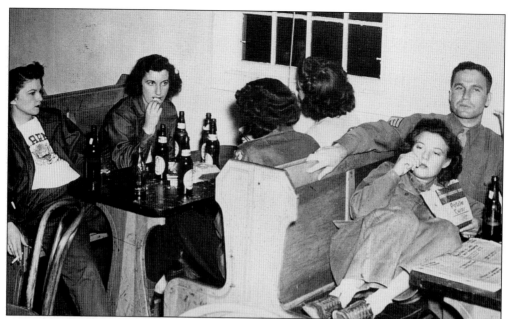

This is how it looked in the Special Engineer Detachment Post Exchange. The Special Engineer Detachment, nicknamed SEDs, was a college-educated bunch who worked in the Technical Area. There were other post exchanges (PXs) around, like the Service Club and the Tech PX, but this one was just for SEDs, and naturally, members of the Women's Army Corps Detachment (WACs) were welcome. (Photograph by John Michnovicz; courtesy of Toni Michnovicz Gibson.)

Students in Central School had classrooms with individual outside entrances and mountain views. Some thought this would be a super school because of the PhD parents, but there were kids playing hooky, practical jokes, and even lice. The school system was organized in 1943 under the direction of Dr. Walter Cook from the University of Minnesota's College of Education, with 140 students enrolled in kindergarten through the 12th grade in its first year.

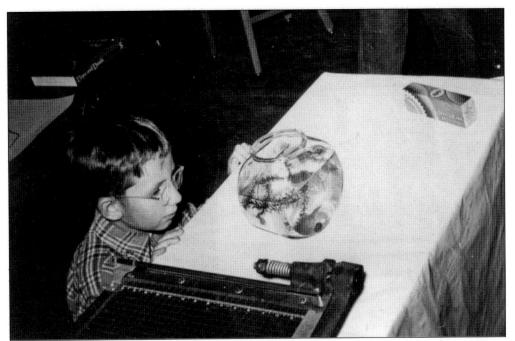

The students were a collection of kids from scientists' families and the local population. Here, Claudio Segrè eyes a fish bowl. His father was Italian physicist Emilio Segrè, who also loved fishing in the area and was happy to report "that the fish bite you, even if you are shouting."

Scientists gathered from the United States and around the world to work on the bomb. Pictured here in the Technical Area of Los Alamos are, from left to right, (front row) Herbert Anderson, Enrico Fermi, John Manley, and Perc King; (second row) Darol Froman, Heinz Barschall, Robert Wilson, unidentified, Seth Neddermeyer, Egon Bretscher, Al Hanson, and Hans Staub.

When Gen. Leslie Groves was assigned to head the Manhattan Engineer District, he was an Army colonel who had just finished building the Pentagon. He was ready to leave construction behind and resume troop command when he received his orders. Some questioned the choice of Groves because of his blunt personality, yet it was Groves's genius that recognized Robert Oppenheimer's ability despite his lack of administration experience and past connections to left-wing friends. He insisted on Oppenheimer's appointment to lead the Manhattan Project. Groves's responsibilities included the Hanford, Oak Ridge, and Los Alamos sites and the evolving problems of technical production, staffing, and housing. Groves stood by his decisions, popular or not, and his command of the Manhattan Project was invaluable to its success. As politics took hold after the war, Groves's arbitrary style offended some, and he was forced to retire from the Army in 1948. (Photograph by John Michnovicz; courtesy of Toni Michnovicz Gibson.)

J. Robert Oppenheimer was serious as a child, masterful in college, and brilliant as a theoretician. When Groves chose him to head the Manhattan Project, Army security balked. Oppenheimer was given the security clearance, though his every move was watched, and all conversations were wiretapped. Oppenheimer wooed and cajoled the best physicists from the United States to join him. His manner was both charming and caustic, but his ability to synthesize discussions and point the direction propelled the Project forward to ultimate success. Afterward, he cautioned for nuclear openness among nations, and that made those who did not like him question him more vigorously. He had scores of supporters, but that did not stop a 1954 hearing to revoke his security clearance, an investigation that was marked by illegal proceedings and personal attacks. For nearly two decades after the war, Oppenheimer was the director of the Institute for Advanced Study at Princeton. He received the Enrico Fermi Award in 1963. (Photograph by John Michnovicz; courtesy of Toni Michnovicz Gibson.)

Raised in Fort Sumner, New Mexico, William Sterling Parsons entered the Naval Academy at age 16. There he was christened "Deacon" because of his last name, and that soon became "Deak." In January 1943, while in combat on board the USS *Cleveland*, Parsons successfully tested the proximity fuze against Japanese aircraft. Later that year, Parsons was chosen for the Manhattan Project, where he became associate director and head of ordnance. About him, Oppenheimer wrote, "He has been almost alone . . . to appreciate the actual military and engineering problems . . . insisting on facing these problems at a date early enough so that we might arrive at their solution." Parsons was in the *Enola Gay* when it took off for Hiroshima. He loaded the gunpowder charge on the trigger device that activated the Little Boy atomic bomb just before it was dropped. Parsons was promoted to rear admiral in January 1946. (Photograph by John Michnovicz; courtesy of Toni Michnovicz Gibson.)

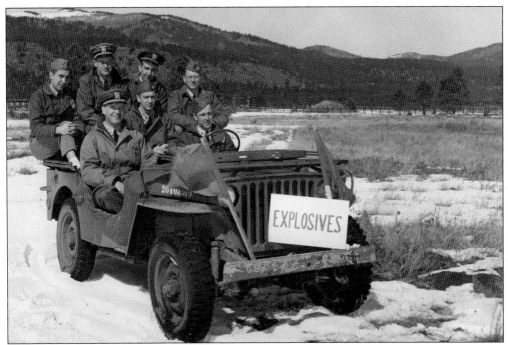

This group of officers, part of the 41 Navy men recruited by Deak Parsons, worked in ordnance testing at S Site. They are, from left to right, (first row) ? Brennan, Edward Wilder, and Gordon C. Chappell; (second row) William A. Wilson, ? Muncey, ? Sullivan, and John H. Russell.

When it took over the Pajarito Plateau, the government acquired Anchor Ranch, located south of Los Alamos, for explosives testing. An existing house there became a mess hall for the working soldiers. Seated on the porch steps of the mess hall are, from left to right, (first row) Charles Wellspring and M. Sisti; (second row) C. Schroeder, C. Bagley, and Benny Sesko.

In August 1943, from left to right, Helen Embree, Marge De Leon, Florence Wilson, and Clarice Scharing arrived in Los Alamos as part of the Women's Army Corps (WAC) Detachment. Between 1943 and 1946, about 300 WACs worked as clerks, drivers, cooks, medical technicians, and scientists. Their dorms were across from the men's barracks, and morning exercises were discontinued after too much enthusiastic whistling was heard from across the street.

Howard Phanstiel (left) and Frances Dunne stand in front of a cabin at an explosives testing site. Dunne, an aircraft mechanic, had small hands, mechanical training, and steel nerves, so she was selected to set triggers on explosives at Two Mile Mesa and in Bayo Canyon. In this photograph, she was on the mend from a break that happened when a cable snapped and hit her leg.

Not all was work. The evenings meant theater, music, movies, or dancing. Residents created their own entertainment because outsiders were not allowed into the Project. The Los Cuatros quartet played for dances regularly. They included, from left to right, John Michnovicz, Ray Gallo, Keith Gard, and "Locky" Lockhart. (Courtesy of Toni Michnovicz Gibson.)

To celebrate Halloween, 15 costumed revelers gathered at the Noncommissioned Officers' (NCO) Club. They are, from left to right, (first row) Louis Jacot, Jeanette Thomas, Marie Sperling, Doris Coleman, Jean Waiter (Dabney), and Winston Dabney; (second row) Mary Whidden (Miller), Arnold Bolnick, Rosemary Burkart (Menz), and Marion Smith (Jacot); (third row) Hans Courant, Paul Sperling, Charles Menz, John Lamb, and Lawrence Bayer. Parentheses indicate married names.

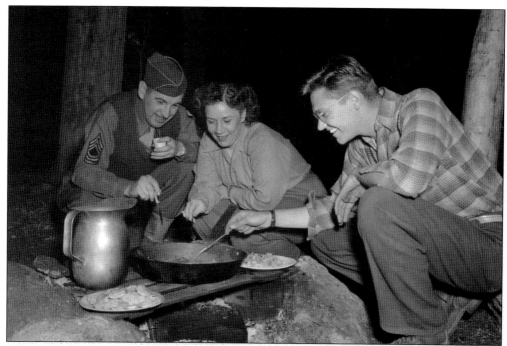

Work on the Project went six days a week, and on Sundays many took advantage of the mountains and canyons for picnics. Here, soldiers Bill ? and John Michnovicz (right) and WAC Nellie Rushing cook steak and potatoes for dinner near Frijoles Canyon. (Courtesy of Toni Michnovicz Gibson.)

Edith Warner's home, just across the Rio Grande River near Otowi Crossing, was a place of respite for scientists and their wives during Project days. She hosted evening dinners that became a popular social pastime for the travel-restricted residents. Her manner was quiet, her dinners were delicious, and her chocolate cake was memorable—many came back for more.

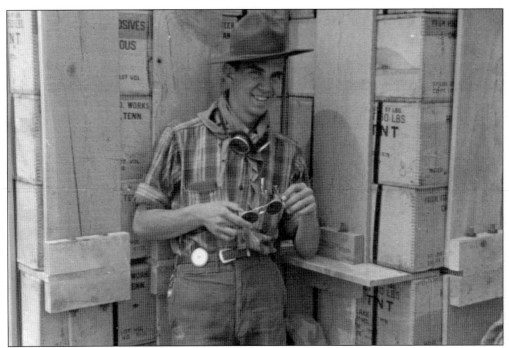

The implosion bomb was tested in Alamogordo, New Mexico, on July 16, 1945. Known as "the Trinity test," the only color image of the explosion came from this man, Jack Aeby, a 21-year-old technician and amateur photographer.

This is one of the three exposures that Jack Aeby took of the Trinity shot on July 16, 1945.

San Ildefonso Pueblo was down the hill from Los Alamos and supplied manpower for the Project. Friendly exchanges between scientists and the Pueblo community developed, and this evening included conversation, square-dancing, and Indian dances. (Photograph by John Michnovicz; courtesy of Toni Michnovicz Gibson.)

On V-J Day in 1945, Americans celebrated the end of the war, and in the barracks at Los Alamos, these SEDs joined in. Shown are, from left to right, (first row) Benny Sesko, Dick Recker, and Benny Decorso; (second row) Chris Schroder, Dexter Wolfe, Bob Potter, Hank Fredrich, Charles Bagley, Sid Levi, and unidentified.

The British Mission joined its American counterparts to work on the bomb. Members included James Tuck, William Penney, Rudolf Peierls, and Otto Frisch. When the war ended, the Brits gave a dinner party for their American hosts. During the evening, the British Mission performed a skit, and Frisch played the role of an Indian housekeeper.

Ernie Titterton, who played the piano at the gala dinner, was another member of the British Mission. Behind him and to his left is his wife, Peggy.

On October 16, 1945, the Army-Navy "E" Award was presented to the Manhattan Project in recognition of its accomplishments. Robert Oppenheimer spoke on that day, which was his last day of work there. "It is our hope that in years to come we may look at this scroll, and all that it signifies with pride." Podium guests included Gen. Leslie Groves and civilians Albert E. Dhyre and Charlotte Serber.

Commodore Deak Parsons signed programs at the end of the "E" award ceremony. On this beautiful New Mexico afternoon, the celebration continued no matter that, soon, change was certain. (Courtesy of Toni Michnovicz Gibson.)

Four

THE TOWN IN TRANSITION

In September 1945, with the war mission accomplished, the exodus began. Many Los Alamos scientists returned to university positions or took jobs in industry. Those who stayed wondered if Los Alamos would become a permanent town. During the war, things were different, but now, the life of muddy roads and temporary housing was less appealing, and the future of nuclear research was unclear.

A man with a vision emerged. Norris Bradbury was named director of the Project, and he promised to address the living conditions in Los Alamos. He believed in the future of nuclear research, so Bradbury agreed to pay the way home for those who were anxious to leave and get to work with those who were likewise committed.

However, on an Army post, the Army provides electricity, garbage pick-up, lighting, food service, and housing, and as troops were discharged, a new work arrangement was necessary. The Army contracted with the Zia Company to take over operations and maintenance. Zia inherited water shortages, gas main failures, and 1,900 employees, who were mostly discharged soldiers and people from surrounding villages and pueblos. Zia was optimistic and promised to deliver "lights, plumbing, electricity, water, heating, garbage, fuel, ice, and wood."

Debates went on in homes and in the halls of Congress about who should control atomic energy. The Atomic Energy Act of 1946 resolved that atomic energy would come under civilian control, so a newly formed Atomic Energy Commission (AEC) could now budget for a permanent town and a new laboratory. Help had arrived to deal with the scarcity of housing and inadequate community facilities. The end-of-war uncertainties were fading away.

Los Alamos opened to the world when the gates came down in 1957. A middle-class town with good jobs was growing. The laboratory had a new name, the Los Alamos Scientific Laboratory. Visitors were welcomed, and dignitaries came. But Cold War–days meant civil defense drills, and in the midst of this nuclear power dance, Russian and American scientists exchanged visits and discussed the peaceful application of the new and massive hydrogen bomb.

Norris Bradbury was a physics professor at Stanford University with a Naval Reserve commission when he was called to active duty in 1941. While at the US Naval Proving Grounds in Dahlgren, Virginia, he worked with Deak Parsons, who later requested that he come to Project Y. There, Bradbury became the field test director of the implosion bomb. After the war, when Robert Oppenheimer asked Bradbury to become laboratory director, he agreed to a six-month stay or until a permanent director was hired. He became that permanent director and stayed on for 25 years. Under his leadership, the military camp was transformed into a modern town. He worked with the Atomic Energy Commission to develop adequate housing, good schools, and places for shopping and recreation in Los Alamos, and he committed many hours to the community as a Boy Scout leader, member of the school board, and speaker at the Science Youth Days. Bradbury was respected and loved and became known as "Mr. Los Alamos." (Courtesy of Toni Michnovicz Gibson.)

John Manley delivers a lecture at a nuclear physics conference called for by leaders of the Manhattan Project. In August 1946, approximately 300 scientists from around the country, including some former Project staff, attended the conference to "assist in establishing the research program of the Project in basic nuclear and fission physics."

At evening cocktail parties during the physics conference, Manhattan Project friends renewed acquaintances. From left to right are Betty Brixner, Eric Jette, Frank Walters, Robert Oppenheimer, and Irma Walters. Eleanor Jette has her back to the camera. At this time, the Jette family lived in this home, but during the Manhattan Project, this ranch school master cottage was the home of Robert Oppenheimer and his family.

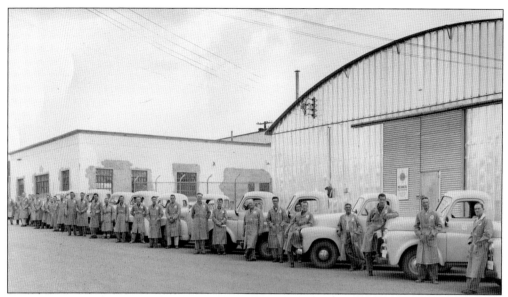

Zia Company employees stand ready for work. When the Zia Company assumed operations and maintenance from the Army in April 1946, it acquired 1,900 employees and responsibilities for roads, utilities, water supply, and sewage systems. At the time of takeover, much of the town needed attention, and coal box repairs were first on the list, according to Zia project manager Elmo Morgan.

E.H. Trapple demonstrates the electric circle-cutting machine for the interested onlookers. On January 11, 1953, the Zia Company hosted an open house to showcase its construction, maintenance, and other shops to family members and the public.

While the US Congress debated the future of Los Alamos and atomic energy and the population clamored for better living, the Army brought in prefabricated housing from closed military installations. This group was the "Hanfords" from Washington State, which was made up of small, single-family units with refrigerators, electric cooking stoves, and indoor plumbing. (Photograph by John Michnovicz; courtesy of Toni Michnovicz Gibson.)

Plans were announced for the first subdivision to be built on a dusty golf course west of town. This staged photograph appeared on the front page of the August 2, 1946, *Los Alamos Times* with the following caption: "Building air castles on the golf course is this golfer who pauses in his round to envisage one of the 300 new dwellings soon to be constructed on the course as Western Housing Development." (Courtesy of Toni Michnovicz Gibson.)

The Western Area was meant to please residents long-accustomed to mud and ruts. New roads followed land contours, and established trees remained. Once the model homes opened, objections to wall-facing kitchen sinks surfaced, prompting the commanding officer to remark, "We cannot expect to provide a custom built job." Some kitchen sinks were moved, construction proceeded, and by the late 1940s, families occupied the dwellings. (Photograph by John Michnovicz; courtesy of Toni Michnovicz Gibson.)

The flurry of housing construction accelerated when the Atomic Energy Act was signed into law, which ensured the permanence of Los Alamos. More housing was needed, so the government built this style of duplex, simply named Group 11, on a mesa north of the central core of the town area.

Ongoing construction brought hundreds of workers who also needed housing. Southeast of town, the temporary camp of White Rock was set up with homes, a school, and a shopping center. At its peak, the population exceeded 1,000, but as construction slowed, the population dropped. The camp was closed in 1957. Private developers started over in the 1960s, and today, White Rock is a community of approximately 6,000.

The Technical Area stood in the center of Los Alamos, but when the Atomic Energy Commission became the governing authority, a new facility, the Los Alamos Scientific Laboratory, took shape on South Mesa across Los Alamos Canyon. The old Technical Area buildings came down, but P-Prime Building, the long building in the foreground, remained until 1964.

The route to South Mesa was on West Road through Los Alamos Canyon. As money poured in from the Atomic Energy Commission for infrastructure, this steel arch bridge, the largest arch bridge in New Mexico at the time, was built 180 feet over the canyon as easier access to South Mesa. (Courtesy of Los Alamos National Laboratory.)

The Otowi Suspension Bridge, now in the National Register of Historic Places, was built in 1924 over the Rio Grande River. The Manhattan Project used it during the war, and it remained in use until 1948 when it was replaced by the truss bridge (center). Edith Warner's home once stood near the group of buildings on the right.

A model of a new commercial development, the Community Center, is on display in the Civic Club. Carroll Tyler, retired Navy captain and newly appointed Santa Fe–area manager of the Atomic Energy Commission, announced a modernization program for Los Alamos that included this commercial area. (Photograph by John Michnovicz; courtesy of Toni Michnovicz Gibson.)

The completed Community Center was structured around a center court with sidewalks that crisscrossed spacious grassy areas. Gone were the mud, dirt, and makeshift buildings, and Los Alamos now had a commercially operated bank, beauty shop, theater, and more.

It was not a sad day when the last shoppers filed out of the military commissary and into this new Safeway grocery store. This anchor store in the Community Center was a big improvement with its tiled floors and large windows that greeted shoppers. The Atomic Energy Commission allowed citizens to operate businesses if they agreed to pay six to ten percent of the gross income to the commission.

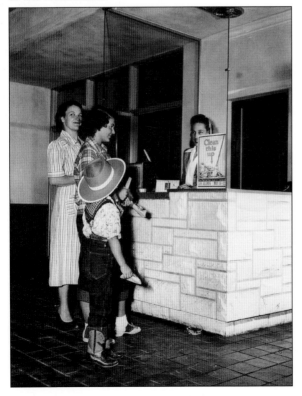

The Centre Theater had a grand opening that included an open house, door prizes, and music by the JAMIC Trio. The opening attraction was *Sitting Pretty*, starring Robert Young, Maureen O'Hara, and Clifton Webb. For tickets, adults paid 45¢, and children were charged 10¢.

Radio KRS broadcasts a live studio performance with Bob Porton (right) as manager. The military first operated KRS out of the Los Alamos Ranch School Big House during the war. After the war the Army granted approval to hire civilians, and Porton, who worked in the station as a soldier, continued working there as a civilian. The station moved to a space in a Technical Area building until a new studio was built in the Community Center. KRS began broadcasting ABC and CBS programming in 1948 and soon became KRSN when it was taken over by the Rio Grande Broadcasting Company. That is when ABC promised top shows . . . and commercials! (Courtesy of Toni Michnovicz Gibson.)

The Atomic Energy Commission's Department of Community Affairs renovated this military post exchange (PX) into a youth center. There was room for a soda fountain, three ping-pong tables, three pool tables, a piano, a jukebox, and games. A crowd gathered at its opening, including, from left to right, Mary Helen Worthington, Ann Brooks, and Betty Armstead. The others are unidentified.

The Los Alamos Scientific Laboratory opened its doors to students as part of Science Youth Days. George Sawyer (right) discusses thermonuclear energy with a group of Los Alamos High School students. They are, from left to right, Ken Cole, David Wong, Rich Miller, Jim Perrin, Jim Lashler, and Richard Leonard. (Courtesy of Los Alamos National Laboratory.)

As housing construction proceeded to the north and west, schools followed. At Aspen School, which opened in 1951 in the North Community, students enjoyed the panoramic view. By 1947, there were more than 800 students enrolled in Los Alamos schools.

The winners of a 1962 speech contest represented six of the almost one dozen schools that peppered the Pajarito Plateau. From left to right are (first row) Debbie Krikorian, of Mountain School (top winner); Dottie Smith, of Aspen School; and Carol Masanz, of Canyon School; (second row) Scott Davis, of Mesa School; Patty Rose, of Central School; and Thomas Schell, of Pajarito School.

Fuller Lodge retained its status as the center of community life when the town was modernized but was renovated to increase hotel space. In 1948, three wings were added, and Fuller Lodge could accommodate up to 75 guests.

This Santa Fe chapel was moved to Los Alamos in 1947 and became the first permanent church building. Catholic, Protestant, and Jewish congregations shared its space. Churches continued to organize, a new Baptist church was built in 1950, and a Catholic parish put down roots in 1951. Behind the trees to the left, the Chapel Apartments are visible.

The first group of the Los Alamos Council Knights of Columbus poses for a photograph at the Charter Installation on May 2, 1948. Invited guests were the archbishop, a representative of the Supreme Council, and knights and ladies from councils in the area. Several fraternal groups were organizing, and outsiders could come to Los Alamos if arrangements for passes were made in advance. (Courtesy of Toni Michnovicz Gibson.)

Residents were prohibited from voting in New Mexico because the military project was considered federal and not state land. An appeal went to the state and federal government, and after a three-year legal battle, civil rights were restored when Los Alamos became a county on June 10, 1949. Officials celebrating are, from left to right, an unidentified man, Earle Sullivan (Atomic Energy Commission), Gov. Thomas Mabry, and George Work.

Cars motor down Trinity Drive to mark the county's first anniversary and encourage voter registration for the upcoming election. The state granted Los Alamos voting rights in 1947, but because the town was administered by the Atomic Energy Commission, state jurisdiction was not recognized. A US congressional decision to retroactively make Los Alamos part of New Mexico made a new county possible, so voters were registered in the citywide drive.

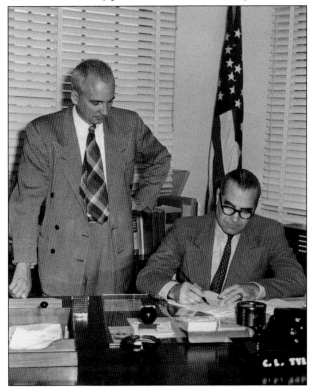

Carroll Tyler, the Atomic Energy Commission's area manager, signs the agreement transferring control of the Los Alamos and White Rock schools from the commission to the Los Alamos Board of Education. Norris Bradbury, head of the Los Alamos Scientific Laboratory and president of the board of education, looks on. The commission retained responsibility for school funding, and the board would now have authority over academic policies.

During the Cold War, Los Alamos developed a "bells and lights" civil defense system to fan out information in an emergency. Sgt. Kenneth Evans demonstrates how it works. When the center dial was rotated, civil defense personnel from Central Control and Field Control Groups would hear an alarm at home or work. They would log in with Evans and proceed to alert their group.

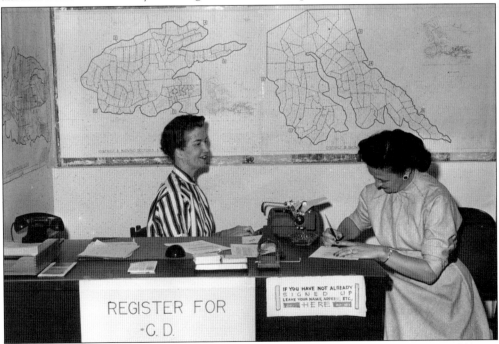

Residents were encouraged to register with the Los Alamos Civil Defense Headquarters. Neighboring communities were surveyed for available housing in case of an emergency in Los Alamos, and volunteers were recruited to organize neighborhoods that were mapped into districts shown in this civil defense office.

The teachers don their civil defense armbands and supervise students as they exit Canyon School in 1955. Readiness plans in the case of an atomic blast included having the room monitor lower the window blinds to shield students from flying glass.

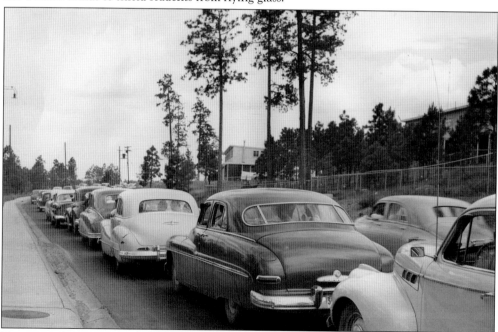

To prepare for an attack, civil defense authorities planned evacuation routes so the community could practice a quick but orderly exit. On June 14, 1954, cars filled with residents from the North Community jammed Diamond Drive to exit Los Alamos. More than 8,000 people left the Hill in one hour.

Ironically, while Los Alamos practiced evacuations, the American and Russian scientists exchanged visits to study atomic energy for peaceful purposes. During a 1959 exchange, Jim Tuck (hands raised) conducts a tour group of Russians. On his left is James Phillips, and Tom Putnam is on his right. Grouped to the right are Russians Vladimir Veksler, Eugeni Piskarev, Igor Golovin, Vasily Emelynov, and Nikolay Dollezhal.

The "Secret City" was opened on February 18, 1957. Townsfolk gathered on that day to see Gov. Edwin Meechem become the first citizen to enter without a pass. The decision to open the town surprised some, as public opinion favored keeping the gates up and the town closed. A year later, little in Los Alamos had changed, except the gate building was a drive-in restaurant.

When he visited Los Alamos on December 7, 1962, Pres. John F. Kennedy was warmly welcomed in his motorcade that moved through town and at his speech in front of thousands at the football field. During the laboratory reception, Mildred Frentzel served his coffee while Virginia Ziebol (left), laboratory director Norris Bradbury (center), and Vice Pres. Lyndon Johnson (right) looked on. Kennedy thanked the community for its preeminent record in service to the country.

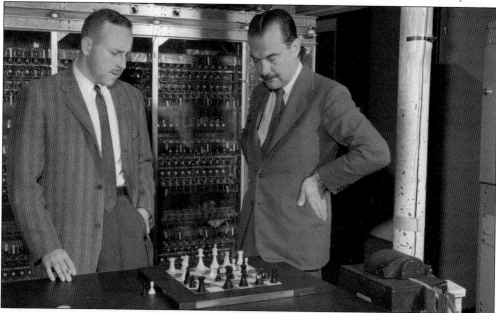

Scientists around the country were building computers with names like ORACLE and AVIDAC, but at Los Alamos, it was the MANIAC (Mathematical and Numerical Integrator and Computer), built by Nick Metropolis (right). Important work on the genetic code started here, but another first was a game of "anticlerical chess" (bishops removed) that Metropolis and Paul Stein (left) played against the MANIAC.

Five

THE ATOMIC CITY

What was it like to live in the atomic city? Opinions might differ, but one fact of life that most folks agreed on was a move toward private property ownership. A 1955 Atomic Energy Commission ruling allowed private home ownership at other nuclear research sites in Tennessee and Washington, but because Los Alamos was considered a security target, the government retained control. Additionally, almost 60 percent of the residences were multiple-family dwellings, which made sales challenging. The Atomic Energy Commission moved slowly toward county independence by surveying and platting property and transferring land to the county. And finally, in 1965, homes went on the market. Anyone living in a single-family unit could buy it. The multiple-family dwellings were sold to senior tenants. New subdivisions were carved out, and demand was so high for the vacant lots that public lotteries were held.

Los Alamos was a town coming into modernity. The original Technical Area where the first scientists worked was coming down, and the Los Alamos Scientific Laboratory was expanding. Streets were widened, and schools were built.

Once destined for a storage closet, Manhattan Project photographs and documents and Robert Oppenheimer's office chair went on display in a makeshift museum in an old Technical Area building. It was so popular that a science museum was built on laboratory property and attracted thousands of visitors.

More people came to see the town and the laboratory. Government officials and sports figures visited. Families came to see the place where dad worked, or students came to learn the science in a world-class institution. And some came to resist. In 1970, during the 25th anniversary of the end of World War II, protestors gathered around Ashley Pond in opposition of nuclear arms development.

There were other complaints, too. But this time, it was coming from Zia, the company that maintained the town. Its workers were on strike almost a dozen times from the 1950s on. Los Alamos was coming into modernity with all of its complexities.

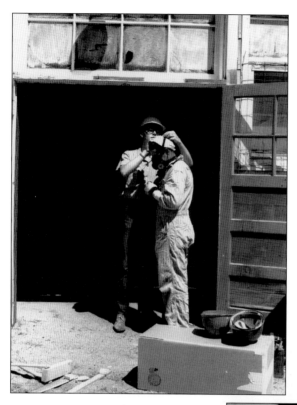

South of Trinity Drive, the footprint of the Technical Area, or TA-1, was vanishing as the last few buildings fell. As he enters old Sigma, this workman is dressed in coveralls and a mask for protection from radioactive dust. Sigma was a metallurgy building that was taken apart by hand. The Atomic Energy Commission planned to use the vacant land for commercial development. (Courtesy of Los Alamos National Laboratory.)

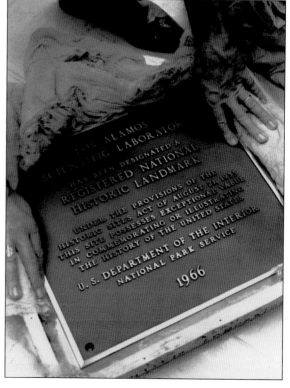

The Los Alamos Scientific Laboratory's old Technical Area was recognized as a National Historic Landmark. At the dedication, this plaque was mounted in a log-and-stone structure on the south side of Ashley Pond, near where the Los Alamos Ranch School icehouse once stood, a building where atomic bomb parts were assembled. Stones from the icehouse were used in this memorial. (Courtesy of Los Alamos National Laboratory.)

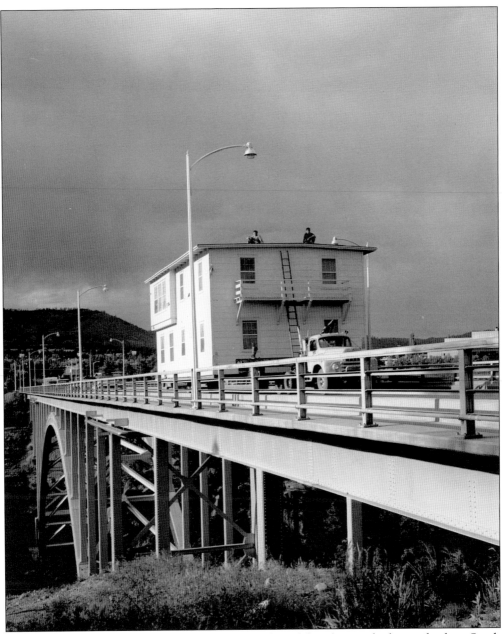

Some thought they were charming and others complained, but the time had come for these Sundt apartments to go. They housed the famous in their time. Enrico Fermi and Edward Teller and their families lived in the Sundt apartments. They were planned to last for five years but were occupied for 20 years, and now, that was ending. The Atomic Energy Commission prepared for "disposal," a move to sell government-owned housing to private owners, by removing the Sundts, as they were thought to be too expensive to maintain. Sundts were priced low, some for as little as $1, because preparation and moving costs were high. The chimneys were removed, the buildings were cut in two, and each half was hoisted onto a flatbed truck for a slow, downhill ride to a new location. Saying goodbye to the Sundts brought Los Alamos one step closer to home ownership. (Courtesy of Los Alamos National Laboratory.)

Concerned citizens recommended that the Atomic Energy Commission develop land for private home ownership. After a lengthy congressional approval process, Barranca Mesa was the first area where lots were sold. At the ground-breaking are, from left to right, Sterling Black (AEC local counsel), Tom Godfrey, John LaMonica, James Teare (chairman of the county commission), Paul Wilson, Darol Froman, and H.W.K. Hartmeyer (chief of the AEC Community Management Branch).

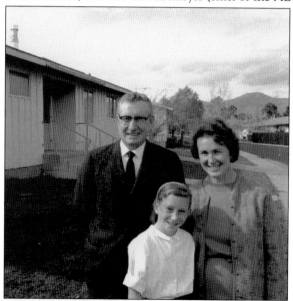

The first home sales in government disposal were in the Eastern Area, and the first owner was William Overton Jr. He paid $7,500 for 289 Manhattan Loop, the three-bedroom home he and his family had occupied for three years. The government completed the Eastern Area home sales with an average of four homes per day and then sold homes in the Western Area. (Courtesy of Los Alamos National Laboratory.)

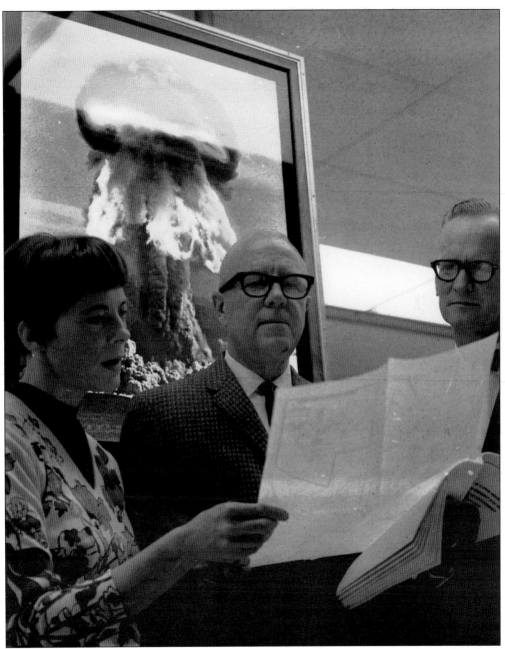

There was a huge push to develop fallout shelter space for all Los Alamos residents when Pres. John F. Kennedy promoted the shelters for civil defense in the 1960s. Los Alamos piloted a shelter readiness program directed by Bob Porton (center), Mary Sue Wooten, and John Schroer. Local donations and US Defense Department funds were used to develop 46 fallout shelters, with space for 15,000 people plus a two-week food supply, sanitation kits, emergency equipment, and radiation monitoring kits. The largest shelter was in the laboratory's Chemistry and Metallurgy Research Building and could house 6,575 people. Above the group was a photographic reminder of atomic danger: the PRISCILLA event from Operation Plumbob that detonated on June 24, 1957, at the Nevada Test Site. (Courtesy of Los Alamos National Laboratory.)

Bob Stapleton listens to a report of radiation conditions during a mock emergency fallout shelter exercise. Under the Los Alamos Civil Defense plan, 70 fallout shelter managers were trained in a 16-hour civil defense class that included an eight-hour stay in a shelter. Shelter managers were taught to organize and structure the shelter routines and supplies and calm fears and anxieties. (Courtesy of Los Alamos National Laboratory.)

A special group took part in the shelter exercise. Members of Girl Scout Troop No. 62 hunkered down for the eight-hour practice and made it look more like fun than anything else.

A crane operator, in two-way communication with a rooftop inspector, lowers a Little Boy bomb casing into the patio of the Science Museum at the Los Alamos Scientific Laboratory. It was the first display of both atomic weapons, Fat Man and Little Boy, since their use in World War II. Their military-green color was coated with white epoxy to withstand the outdoor weather. (Courtesy of Los Alamos National Laboratory.)

The third Los Alamos Family Days attracted 20,000 visitors in 1965, including David Noland, who crawls among a set of traced footprints from Pres. John F. Kennedy's 1962 visit to the Chemistry and Metallurgy Research Facility. Visitors could see the laboratory, technical sites, Zia Company, the Atomic Energy Commission, and drive to S Site, where they could have lunch in the cafeteria. (Courtesy of Los Alamos National Laboratory.)

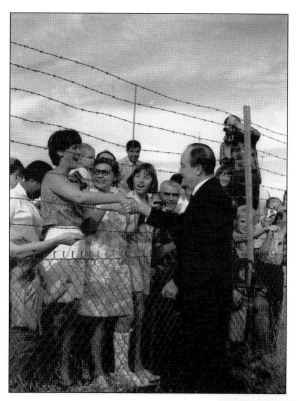

Vice Pres. Hubert Humphrey dropped in at the Los Alamos Scientific Laboratory and greeted well-wishers through the barbed-wire fence at the airport. His visit was confirmed the night before he arrived, and in three hours, he managed to tour the laboratory, visit the science museum, and attend a reception after which he went to Santa Fe for his scheduled weekend of rest. (Courtesy of Los Alamos National Laboratory.)

Just before boarding a bus to tour the laboratory, California governor Ronald Reagan is greeted by Bob Porton. Reagan came to the Los Alamos Scientific Laboratory with the University of California's Board of Regents when a new contract was signed between the laboratory and the University of California, the laboratory's governing body. Reagan spoke of the pride that the university felt in its "outpost campus" in Los Alamos.

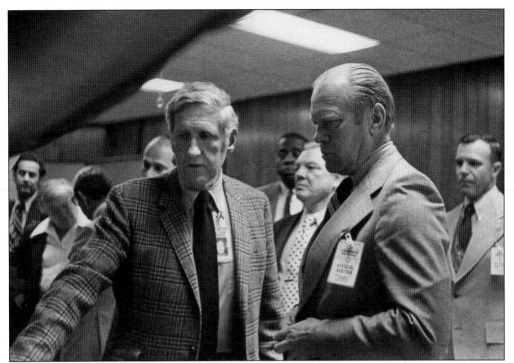

Vice Pres. Gerald Ford was briefed on laboratory programs by Los Alamos Scientific Laboratory director Harold Agnew (left). At the back left is Dr. Dixy Lee Ray, the Atomic Energy Commission chairperson. Agnew came to Los Alamos in 1943 and flew as a crewmember in one of the planes during the strike on Hiroshima. He led the Weapons Division for several years and was laboratory director from 1970 to 1979.

Visitors were not unique to Los Alamos, but it was the altitude and not the laboratory that attracted the US Olympics women's track team. Mexico City, the scene of the 1968 Olympics, had an altitude comparable to Los Alamos, so the US team trained in Los Alamos to prepare for the October Olympic Games.

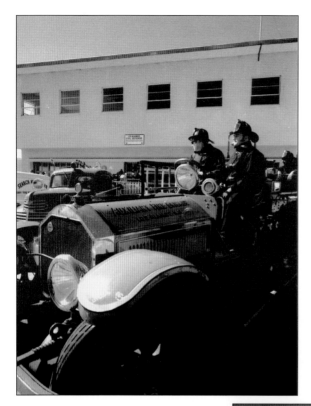

The Los Alamos Auxiliary Fire Brigade members stand on their restored 1921 fire truck. The brigade was organized in 1952 as back up to the regular firefighting force. It also provided volunteer ambulance service and first aid instruction, and firefighters proudly displayed their restored vehicles and pinstripe uniforms in parades. Today, they serve in wildfire fighting, search and rescue operations, and community events. (Courtesy of Los Alamos National Laboratory.)

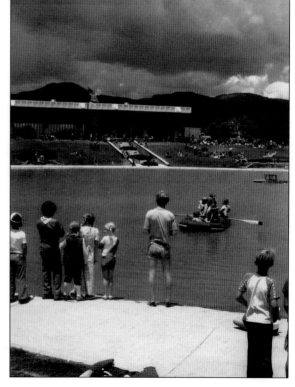

The Atomic Energy Commission spent more than $8 million to prepare the county to become an independent municipality. One of those projects was the county building, which the commission built on the edge of Ashley Pond. The area nearby became a popular spot, and for the bicentennial, Boy Scouts gave rides on the pond. Structural defects were determined in 2007, and the county building was torn down. (Courtesy of Los Alamos National Laboratory.)

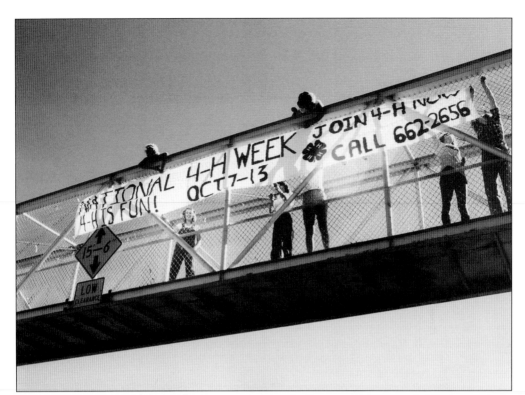

The Stitch-n-Stir 4-H club members, including Marie Christman (standing, left), hang their banner on the pedestrian overpass near the high school above Diamond Drive. To improve traffic flow, the Atomic Energy Commission removed street-level pedestrian crossings there and created the overpass, which soon became the place for community announcements. (Courtesy of Corine and Ron Christman.)

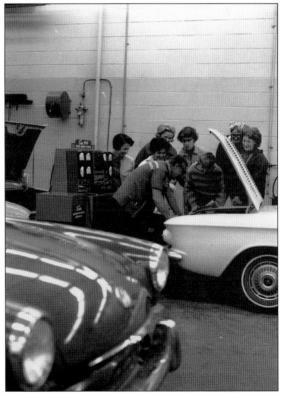

The Los Alamos School System sponsored community education courses for several decades, and offerings ranged from meteorology to shorthand. In this class titled "What's Cooking Under Your Hood," which was for women only, students could learn the inner workings of their cars. (Courtesy of Los Alamos National Laboratory.)

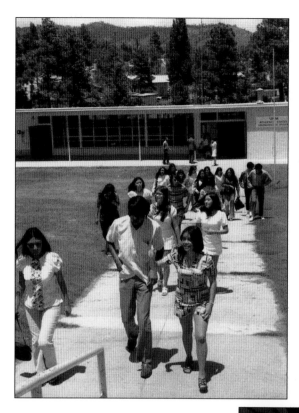

Educators that represented Los Alamos and surrounding area schools, New Mexico pueblos, and the laboratory formed the Residence Center Advisory Council to provide an undergraduate education for students in northern New Mexico. The Los Alamos Residence Center, in the vacated Little Valley School, started with 200 students in 51 courses taught by local professionals. It eventually became the University of New Mexico–Los Alamos. (Courtesy of Los Alamos National Laboratory.)

Elbie Mendenhall, pilot for Carco air service, approaches the landing strip in Los Alamos. In 1946, Clark Carr's proposal for air service between Los Alamos and Albuquerque, contingent on the laboratory building the airstrip, was approved by the laboratory and the Air Force. Carco flew lab employees on seven round-trips daily and built a safety record of 100,000,000 miles flown without injury. (Courtesy of Los Alamos National Laboratory.)

In Zia Company's early days, many union shops were organizing, including laborers, painters, decorators and paperhangers, plumbers and steamfitters, and operating engineers. Several strikes occurred between 1958 and 1980. When one local called a strike, other shops would join in sympathy and hundreds of workers would be out. The longest strike, over wage scales, was a 56-day work stoppage in 1960 that interrupted a school expansion. (Courtesy Palace of the Governors Photo Archives NMHM/DCA 030058.)

The nuclear protests of the 1970s and 1980s that took place around the country combined concerns about nuclear weaponry and waste. The place to gather in Los Alamos was around Ashley Pond, and protestors and onlookers gathered there in 1983 to remember Hiroshima. A previous demonstration on the 25th anniversary of the Hiroshima blast attracted about 150 demonstrators for a night vigil, a film about Hiroshima, and peace lanterns on the pond.

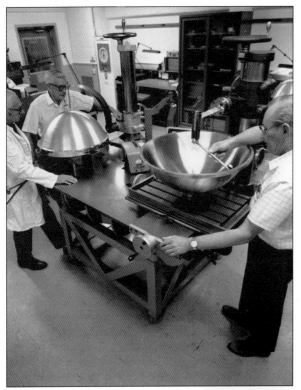

In SD-4, the Shop Department's Inspection Group, machined apparatus and tools made in other SD shops or by outside vendors are inspected for flaws and checked for correct tolerances, sometimes with exactness as small as 10-millionths of an inch. In this photograph, from left to right, Jim Clayton, Eugene Roach, and Jim Snyder use a sweep gauge to measure the inside radii of a hemisphere. (Courtesy of Los Alamos National Laboratory.)

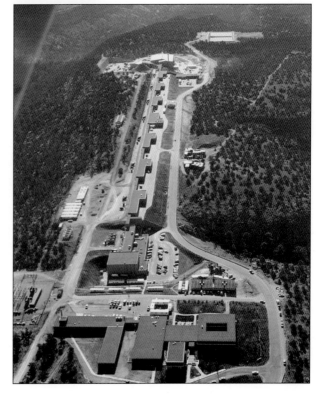

The 1970s Los Alamos Meson Physics Facility dominates the eastern stretch of Mesita de Los Alamos, one of the many finger-like mesas where Los Alamos National Laboratory sites are located. The laboratory now occupies 36 square miles, employs more than 10,000 people, and has broadened research to include security, environmental, and energy programs.

Six

TAKING TIME FOR FUN

Taking time for fun could mean getting away from it all to enjoy the beauty and natural resources of the Pajarito Plateau with its enthroned Jemez Mountain backdrop. Or maybe, it was organizing fellow travelers to sing, dance, or play baseball. For one-time or all-the-time residents of Los Alamos, there was lots of outdoor and homemade fun.

Take hiking and picnicking. Bandelier National Monument was south, Puyé Cliffs to the north, and cliff dwellings and petroglyphs in between. If one was lucky enough to own a horse, the plateau was truly a playground, as trails from Los Alamos Ranch School times covered the area.

What about winter sports? The Manhattan Project scientists and soldiers loved to ski the area and initiated improvements on Sawyer's Hill. Special Engineer Detachment soldiers cobbled together a rope tow. An old car engine powered the pulleys that were made with wheel parts from a Model A. They charged a little bit to recoup their costs but were informed that the military could not operate a private business. So the Sawyer's Hill Ski Tow Association was born. A couple of years later, it became the Los Alamos Ski Club, a volunteer group that over the years donated hours, money, and expertise to improve skiing on the plateau. Down in Los Alamos Canyon, a small, shady pond was used for ice-skating. Over time it was enlarged for hockey, and the players even had their own Zamboni.

They were a clubby bunch, those Los Alamos folks. They had to be because during Project days they could not leave the site easily, so they grew their own entertainment, dancing, singing, acting, and sports. It thrived then and still does now, this homemade society of clubs, craft organizations, Girl Scouts, Boy Scouts, horse associations, film society, theater, art, and baseball. In fact, one baseball team, Pierotti's Clowns, known for its winning antics and fundraising flair, played its way right into the very first issue of *Sports Illustrated* magazine.

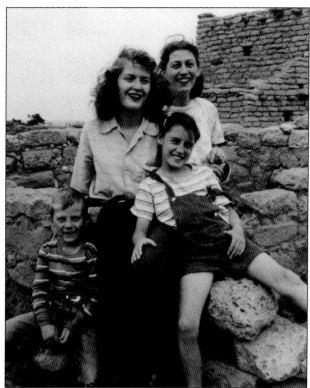

Mary Lou Maloney (left) hikes around Puyé Cliffs with her friend Katie Lacey and Katie's children, David and Pat. The mesa top dwelling behind them was part of the Puyé Cliffs ruins, excavated in 1907 by Edgar Hewett. Katie's husband, Herman, and Maloney worked for the Manhattan Project, and Puyé Cliffs was a popular hiking and picnicking spot for them. (Photograph by John Michnovicz; courtesy of Toni Michnovicz Gibson.)

Project scientists welcomed a relaxing Sunday drive on the road to Los Alamos after the six-day workweek. This group stopped to enjoy the panorama of cliffs and canyons. Larry Langer and his wife, Bea, are in the front, and seated in the back are William Penney (left) and Emil Konopinski. Penney later became head of the British Atomic Energy Commission.

Special Engineer Detachment soldiers Paul Farrar (left) and John Michnovicz share the ice on a small pond in Los Alamos Canyon. The frozen pond was used first by ranch school students, and during the Manhattan Project, the rink was so popular that the Army provided a hutment for warming and used a tractor to clear the ice of pine needles, snow, and debris. (Courtesy of Toni Michnovicz Gibson.)

The ice rink was fenced, skaters organized the Los Alamos Skating Association, and an old dormitory building was moved to the canyon and remodeled into a new warming center (in the upper left). The shady location was usually ideal; however, members hung flaps of fabric over the wires across the rink to keep the sun from melting the ice, just in case. (Courtesy of Los Alamos National Laboratory.)

In 1948, the Los Alamos Sheriff's Posse was organized to promote horsemanship, assist in mounted patrols, and support the Junior Posse and 4-H youth activities. Members built the "Posse Shack" using lumber, windows, and doors from the Technical Area demolition and held meetings and entertainment there. Band members on this evening are, from left to right, Willie Williams, Juffy Harelson, Joinney Hines, Betty Lou Stein, and Leo Rudel.

The Junior Posse in front of the Posse Shack are, from left to right, (first row) Carol Thomas, Donna Pederson, Alana Olcott, Mike Johnson, Barbara Motz, Janet Reavis, and Susan Stewart; (second row) Debbie McClain, Jan Johnson, Eric Holm, Holly Reynolds, Kathy McClain, Kelly Lujan, Karen Ellesberry, Charla Bequette, Donna Crook, and Sheila Lujan. The Junior Posse was organized for horse-riding youth from eight to 18 years of age.

102

Horse owners have attended the stables on North Mesa for many years. Horses were stabled during Manhattan Project days in the old Manuel Lujan homestead area. Interest grew, the Sheriff's Posse organized, and the stables moved east. There were more than 100 corrals for horses, ponies, one burro, and several sheep, and a rodeo grounds was added. The property is now county-owned, and the Stable Owners Association represents the voice of horse owners and enthusiasts.

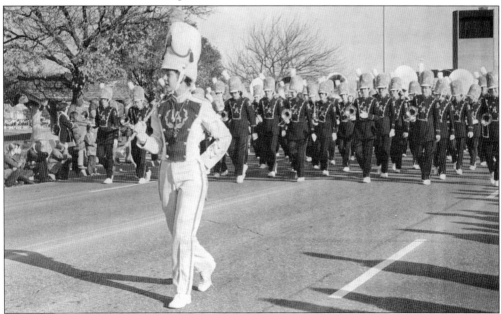

The Los Alamos High School marching band parades down Central Avenue during county fair days. The Los Alamos County Fair and Rodeo is an annual event with rodeo queens, calf roping, bull riding, musical entertainment, and barbecue dinners. Rodeos date back to the late 1940s when an area near the golf course was the scene of bareback riding, goat roping, and wild cow milking.

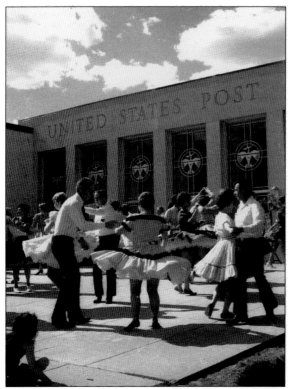

The Mountain Mixers Square Dance Club performs in front of the post office during the Los Alamos Bicentennial Celebration. George and Dorothy Hillhouse came to the Manhattan Project and brought square dancing with them. Hillhouse called weekly dances, and as Los Alamos grew, so did the popularity of square-dancing. At times, as many as 80 people square-danced in Fuller Lodge. (Courtesy of Los Alamos National Laboratory.)

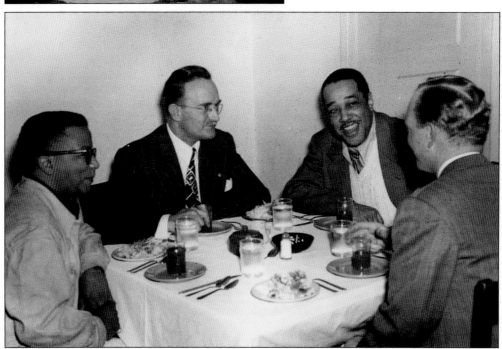

Dinner was served at the Civic Club for special occasions, and the arrival of Duke Ellington was one of them. He was in town for a concert with collaborator Billy Strayhorn (left). Earle Sullivan, of the Atomic Energy Commission, is seated to Ellington's right.

A highlight of the Los Alamos Light Opera came in 1960 with *South Pacific* on stage and Don McCormick as Billis. Dedicated volunteers and staying power describe the Los Alamos Light Opera. Manhattan Project residents organized an orchestra, community chorale, and a theater society, but most of the work was serious. They yearned for something lighter, so they joined forces for their 1948 production of Gilbert and Sullivan's *HMS Pinafore*. Since then, they have staged *My Fair Lady, Cabaret, Showboat, Fiddler on the Roof, 1776* (in 1976), and numerous others and have not missed a year. Arno Roensch, Dick Money, Eric Jette, Jerry Kellogg, Helene and Bergen Suydam, Raemer Schreiber, and Nerses Krikorian are among the many alumni of past productions that have contributed their talents, dancing, and singing. (Courtesy of Los Alamos National Laboratory.)

Boy Scout Troop No. 22 displays a camp table and bench at the Boy Scout Jamboree in Santa Fe in 1947. Troop No. 22 was the first organized in 1917 as part of the Los Alamos Ranch School. It was reorganized after the war, and from there, scouting grew to several Boy Scout and Cub Scout packs with hundreds of boys. Troop No. 22 is one that still exists today.

Atomic Energy Commission conservationist Homer Pickens shows the Boy Scouts how to build a quail shelter from discarded Christmas trees. The event was the annual Project Christmas Tree as Boy Scouts collected trees to fill arroyos to protect them from erosion and build small animal habitats. The Scouts partnered with a local conservation organization, the Isaak Walton League, for the project. (Courtesy of Los Alamos National Laboratory.)

The weather was perfect for the first soapbox derby in 1964. Each boy obtained the $36.50 needed for supplies from a sponsor and built his own car. The Los Alamos Jaycees and Art Houle Chevrolet provided T-shirts, the track, and timers for 50 contestants who raced two at a time down a 975-foot course along Central Avenue. (Courtesy of Los Alamos National Laboratory.)

Jerry Morton (left) and Russell Sullivan, seniors at Los Alamos High School, were first place rubber raft winners in the Annual Rio Grande Whitewater Race. This was billed as the "under 21" race when, for the first time, entrants who were under 21 years of age could race in the rubber raft or kayak division if both parents consented. They beat teams of teachers and laboratory personnel in the 4.4-mile event. (Courtesy of Los Alamos National Laboratory.)

Golfing improved dramatically from the dusty course west of town that the Manhattan Project golfers used. The Atomic Energy Commission built the new course at the foot of the Jemez Mountains in 1947. Visible on the far right in the foothills are Pajarito Elementary School's gymnasium and rooftops of homes on Woodland and Arizona Avenues. Today, the golf course is owned and operated by Los Alamos County.

"Sluggin'" Jim Getker of the Los Alamos Atomic Bombers runs toward home after his grand slam that beat the Santa Fe Miller Motors. After the war, 25 men's and women's baseball and softball teams played on the Big House, McKee, and the golf course fields. Baseball was so popular that, by 1960, there were 52 teams for men, women, and children playing Monday through Friday.

By far, the most popular and unusual softball team in Los Alamos was Pierotti's Clowns. Lou Pierotti was convinced that only five men were necessary to play fast pitch softball and win. He found five ballplayers, dressed them in clown faces, and managed the only five-man amateur team in the nation to play for 25 years, post a 176–23 record, and raise $200,000 for charity. They hammed up the game for the crowds with their trash can lids for gloves, on-the-knees batting stance, and mid-game naps. It was not all ham though because pitcher Bun Ryan could throw the ball 100 miles per hour. Opponents included the Albuquerque Dukes and the state penitentiary team. Pierotti's Clowns were featured in the first issue of *Sports Illustrated* magazine in 1954. The team members with their clown faces are, from left to right, (first row) Ted Godwin, Lou Pierotti with son Michael on his lap, and Stan Ewing; (second row) Walter Garcia, Bun Ryan, and J.L. "Robbie" Robinson.

The soldiers got their Sawyer's Hill rope tow together with used auto parts, but it was not without its dangers. The posted warnings for users read, "Do not use tow unless properly instructed and keep loose clothing away from rope." However, the skiers were not deterred. (Photograph by John Michnovicz; courtesy of Toni Michnovicz Gibson.)

In the 1948 Los Alamos Ski Club lodge are, from left to right, (first row) Evelyn Kline, unidentified, Mary Huston Burgus, Faith Schell, Mary Jean Nilsson, Lore Watt, Elise Cunningham, Carl R. Buckland Jr., Mary Ella Buckland, Carl Buckland, Dottie Franz Jones, Betsy VanDuran, Fran Forbes, Al Spano, Henrietta Nyer and son, Terry Davis, and Neil Davis; (second row) Art Hemmendinger, Jim Coon, unidentified, Clif Nilsson, Bob Watt, John Orndoff, and Al VanDuran.

When it came time to update things, the Los Alamos Ski Club was there. It was a member-operated organization, which meant members did the work necessary to clear ski runs, improve tows, and repair the lodge. Maintaining ski runs was hard work, and when families brought the children, even the youngest pitched in to help. (Courtesy of Los Alamos National Laboratory.)

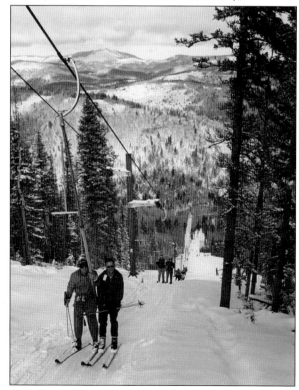

A major move to Pajarito Mountain from Sawyer's Hill in the late 1950s eventually brought this Poma Lift. The rope tows that were used at Pajarito were known to be difficult and to challenge even the most muscular, so this T-bar was an improvement. The ski association did much of the backbreaking work to clear land, and the Robert McKee Construction Company raised poles, towers, and terminals for the project.

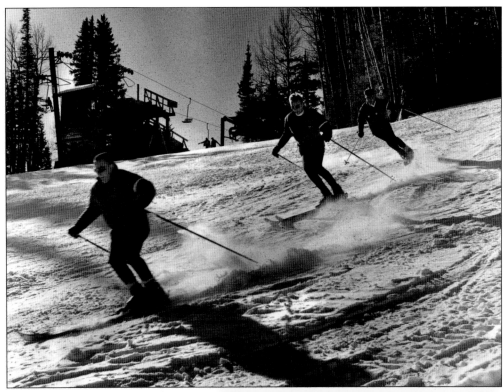

The ski club continued to perfect the area when it completed the Lone Spruce chair, the first chair lift on Pajarito Mountain. Skiers now moved at a rate of 1,200 per hour on the lift. Three Pajarito Mountain Ski School instructors take advantage of the lift on an early morning run down the mountain. They are, from left to right, Duane Roehling (director), Don Parker, and Dick Lewis.

The youngest skiers were welcomed with classes for peewees. And those who were too young or too tired to ski could always go along for the ride on dad's back. (Courtesy of Los Alamos National Laboratory.)

Seven

DESTRUCTION AND PRESERVATION

Many conflicts between destruction and preservation have occurred on the Pajarito Plateau: the ravages of nature against man-made structures, hazardous materials in the environment, and time's slow erosion of history.

The most devastating destruction came when the Cerro Grande fire burned more than 47,000 acres of forest, destroying homes in Los Alamos and buildings at Los Alamos National Laboratory. Though previous fires had struck blows to the county and nearby Bandelier National Monument, Cerro Grande tested the town's 20,000 residents, but it did not win. Spirit and community prevailed. Neighbor helped neighbor with abundant generosity. Displaced residents lived for many months in Femaville, a collection of government trailer homes on North Mesa, but the lost homes were eventually rebuilt.

Another worry for many as the fire raged through town was the fate of the historic district, buildings erected by the Los Alamos Ranch School, used later by Manhattan Project scientists, and treasured by the community. Though the structures were spared by the fire, preservation is necessary to maintain these oldest buildings so that Fuller Lodge, in the National Register of Historic Places, continues to stand with Bathtub Row and Oppenheimer House. These revered buildings are accompanied by the Romero Cabin, a relocated and restored remnant of the homestead era.

The two most significant Manhattan Project sites also survived the fire, though some parts were damaged. The Gun Site and the High Bay at V-Site will be the interpretative centerpieces for the Los Alamos portions of the proposed Manhattan Project National Historical Park. The V-Site has been restored with a grant awarded through Save America's Treasures by the National Park Service, and Gun Site restoration will follow.

Fires, weathering, and erosion have taken a toll on archaeological evidence of Indian occupation on the Pajarito Plateau, which dates to the 13th century, but the laboratory complies with the Antiquities Act of 1906 in protecting or excavating ruins that may be disturbed. Laboratory archaeologists have studied and surveyed the ruins since the late 1940s in an effort to preserve the natural environment. Inherent in the work of the laboratory are other hazards that occasionally result in cleanup procedures and decommissioning of facilities.

In the spring of 1967, the Barranca Mesa fire threatened homes and served as a wake-up call for the potential destruction from forest fires within the townsite of Los Alamos. Firemen and residents joined forces to quickly control the fire and limit the loss to 10 acres of forest with no homes damaged. (Courtesy of Los Alamos National Laboratory.)

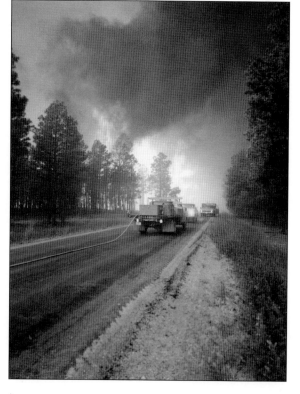

In 1977, the La Mesa fire began in an isolated section of Bandelier National Monument and spread across the Pajarito Plateau to encroach on the Los Alamos National Laboratory, destroying more than 15,000 acres, but it served as an opportunity for scientists to study and improve fire management and recovery. The results produced optimism that future fires might be better controlled and therefore of a less serious nature.

Defeating the hope that lessons learned from previous fires would help prevent serious disaster, the Cerro Grande fire roared into Los Alamos in 2000 as an "out-of-control inferno," becoming the largest forest fire in New Mexico history. Bandelier National Monument, the Santa Fe National Forest, Los Alamos National Laboratory, Los Alamos County, and Santa Clara and San Ildefonso Indian Reservations all suffered losses. (Courtesy of Los Alamos National Laboratory.)

On May 4, 2000, a fire crew from Bandelier National Monument started a prescribed burn at Cerro Grande. Within hours, increasing winds sent the fire out of control. On May 10, it entered Los Alamos on its path of destruction of some 47,000 acres. Communities from New Mexico, across the United States, and as far away as sister city Sarov, Russia, responded with compassion and aide. (Courtesy of Los Alamos National Laboratory.)

Los Alamos was evacuated on May 10, and at 1 a.m. the next morning, a second evacuation included the suburb of White Rock. Neighboring communities set up shelters and offered their support to the 20,000 people streaming out of Los Alamos. Ultimately, some 400 families lost their homes to the Cerro Grande fire. (Courtesy of Sharon Snyder.)

A resident returns to find that a burned-out water heater and its associated plumbing are the only recognizable features of his home. Ray Poore, who documented the aftermath with more than 450 images, took this photograph two weeks after the fire.

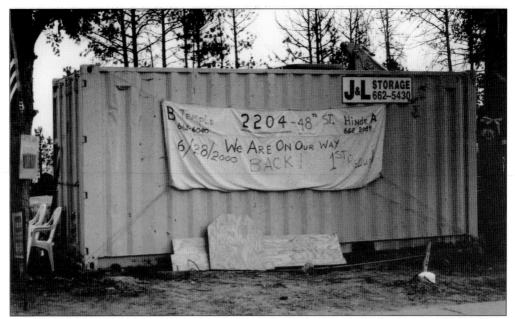

Before the fire, the Temple and Hinde families shared a duplex in Northern Area. By late June, they had cleared their lot of debris and declared intentions to be the first to rebuild. Their spirit epitomized the determination of Los Alamos residents to reclaim their town despite $1 billion in property damage that included more than 100 Los Alamos National Laboratory structures, as well as homes. (Courtesy of Sharon Snyder.)

Originally a cottage at the ranch school, this Bathtub Row house was occupied during World War II by J. Robert Oppenheimer and his family. In 2004, the Oppenheimer House was donated to the Los Alamos Historical Society through the generosity of longtime residents Bergen and Helene Suydam by way of a life trust that allows the Suydams to remain in their home as long as they desire. (Courtesy of Larry Campbell.)

The crown jewel of the Los Alamos Historic District, Fuller Lodge was designed by famed Santa Fe architect John Gaw Meem and built in 1929 as a dining and residence facility for the Los Alamos Ranch School. The scientists of the Manhattan Project dined there as well, and today, the lodge is a treasured community centerpiece used for gatherings, concerts, and celebrations. (Courtesy of Heather McClenahan.)

The Romero Cabin, a homestead that originally stood beside Pajarito Road, was relocated to its present site near Fuller Lodge in 1985. When fully restored, the cabin was furnished with period artifacts to interpret the homestead era of Pajarito Plateau history. This project was led by Larry Campbell and the "Cabin Guys," John Ruminer, Tom Sandford, and Gerry Strickfaden. (Courtesy of Larry Campbell.)

The Gun Site is one of the two most significant Manhattan Project structures still standing at Los Alamos. Ballistics tests for the gun-type method of detonation used in the uranium bomb dropped on Hiroshima were conducted here. Results produced by conventional artillery were viewed through a periscope from the safety of this facility built into the hillside. (Courtesy of Los Alamos National Laboratory.)

A cluster of wooden buildings at V-Site has been restored. The Gadget, an implosion device that was the prototype for the Fat Man bomb, was assembled here before its detonation at Trinity Site. A high explosives handling and assembly facility, V-Site was one of the most secret places at Project Y, the World War II code name for Los Alamos. (Courtesy of Los Alamos National Laboratory.)

With hundreds of pre-Columbian sites on the Pajarito Plateau, the study and preservation of ruins has gone hand-in-hand with the growth of the national laboratory. Surveys and excavations have been conducted, as seen with this excavation at TA-46 in the summer of 1963, with the help of Zia Company maintenance and operations workers who assisted on digs for more than 15 years.

The American Recovery and Reinvestment Act funded the decontamination and decommissioning of DP Site, where plutonium and uranium research and contaminated waste disposal dated back to the Manhattan Project days. The environmental cleanup involved approximately six acres and a goal of returning the land to residential standards. (Courtesy of Los Alamos National Laboratory.)

Eight

RECONNECTING

What is it that produces a yearning to return to certain places? Is it a desire to reconnect with accomplishments, with emotions, with a former self or ancestors at a point in time? Whatever it is, many people of different races and cultures have formed a bond with Los Alamos and the Pajarito Plateau: Native Americans who return to ruins of spiritual significance, descendants of homesteaders, ranch school students and their masters, scientists who came as young men and left with a sobering wisdom, and others who simply came of age in this special place. For various reasons, they make their way back.

The plateau is a multilayered landscape, one that has known turmoil and tranquility. It is a site that man has occupied for hundreds of years. It has a cultural heritage unlike any other, from Native Americans who hunted here with arrows to men who changed the world with their scientific discoveries. It is impossible to walk on the mesas or in the canyons without feeling the spirits of those who went before.

Edith Warner, the woman who lived in the house at Otowi Bridge, believed that "there are places on the earth—actual physical places—where the great powers are much closer, much more available . . . and that this is such a place." Perhaps it is.

Laboratory director Norris Bradbury and Dorothy McKibbin, the gatekeeper to Los Alamos, admire the commemorative plaque at 109 East Palace, Santa Fe's Manhattan Project Office. "All the men and women who made the first atomic bomb passed through this portal to their secret mission at Los Alamos. Their creation in 27 months of the weapons that ended World War II was one of the greatest scientific achievements of all time."

From left to right, Manhattan Project scientists and Nobel laureates Edwin McMillan, Emilio Segrè, I.I. Rabi, Hans Bethe, and Luis Alvarez returned for the 40th anniversary of the Los Alamos National Laboratory in 1983. Behind them is the J. Robert Oppenheimer Study Center, a research library renamed on the occasion of this anniversary to honor the director of the Manhattan Project.

At the 50th anniversary of the Los Alamos National Laboratory in 1993, three former laboratory directors accompanied the current director, Sig Hecker, at the celebration events. From left to right are Donald Kerr (1979–1986), Hecker (1986–1997), Norris Bradbury (1945–1970), and Harold Agnew (1970–1979).

Lt. Gen. Austin Betts (right) speaks with former master sergeant Gerald Tenney and his wife at a Los Alamos veterans' reunion in 1970. More than 600 Manhattan Project military personnel attended the event that celebrated the 25th anniversary of the end of World War II. They returned to a town that had totally changed but also to friendships forged in the wartime years. (Courtesy of Los Alamos National Laboratory.)

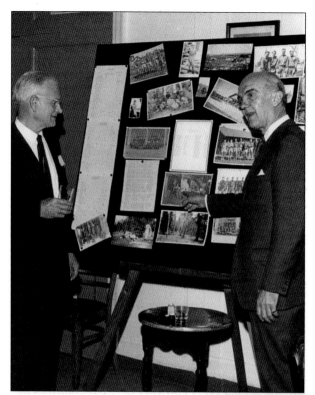

Former Los Alamos Ranch School headmaster Lawrence Hitchcock and master Oscar Steege revive memories of students and good times at a ranch school reunion in 1973. Both men were Latin scholars and members of the core faculty. When the school closed in 1943, Hitchcock served in World War II as a colonel in the Army, and Steege served in the Navy as a lieutenant commander.

Former Los Alamos Ranch School student Baird Tenney stands alone with his memories in Fuller Lodge during the 1973 reunion. Holding his Stetson and wearing his original ranch school uniform, his reflections may have mirrored those of a 1934 graduate who recalled, "It was the best year of my life." (Courtesy of Los Alamos National Laboratory.)

Mac Hopper stands beside the remnants of a fireplace that was part of his homestead cabin on Los Alamos Mesa around 1914. Hopper partnered with Harold Brook in creating the Los Alamos Ranch, which later became the Los Alamos Ranch School. Hopper returned to visit the site in the early 1950s with Frank Brown, son of Cassy Brook.

In 1974, the Los Alamos Historical Society published its first book, *When Los Alamos was a Ranch School*, by Fermor and Peggy Pond Church. A garden book signing drew many longtime friends back to Los Alamos. Seated are, from left to right, ranch school master Fermor Church, Evelyn Frey, unidentified, and photographer Laura Gilpin. Standing are, from left to right, Hugh Church, Peggy Pond Church, Maxine Joppa, and Jim Lilienthal.

Bences Gonzales, a homesteader descendant, lived through three historic eras on the Pajarito Plateau. He helped his wife's father build the Romero Cabin, was an indispensable employee at the Los Alamos Ranch School, and ran a post exchange for the Manhattan Project. In 1959, he and his son Raymond returned to visit the old Romero homestead, which was, by then, showing the passage of time.

Marcos Gomez built this cabin for his bride, Maria, in 1937. In October 1974, they returned for a last look at their homestead, located on Two Mile Mesa in a restricted area of the Los Alamos Scientific Laboratory. The remains of Maria's cook stove and an old washtub survived to remind them of the early days of their married life on the Pajarito Plateau.

The name most associated with Los Alamos is J. Robert Oppenheimer, the man who put a little mountain town on the world map. William H. Regan took this photograph in 1964 when Oppenheimer made his first public appearance in Los Alamos since 1945 to give a speech at the Civic Auditorium. As he waves to onlookers, he is accompanied by laboratory director Norris Bradbury, who gave the opening remarks and introduced Oppenheimer to an overflow audience that evening. Shortly after this visit, the J. Robert Oppenheimer Memorial Committee was founded to further his memory and spirit. Its rationale lies in Oppenheimer's own words: "We know that our work is rightly both an instrument and an end. A great discovery is a thing of beauty; and our faith—our binding, quiet faith—is that knowledge is good and good in itself. It is also an instrument; it is an instrument for our successors, who will use it to probe elsewhere and more deeply; it is an instrument for technology, for the practical arts, and for man's affairs."

www.arcadiapublishing.com

Discover books about the town where you grew up, the cities where your friends and families live, the town where your parents met, or even that retirement spot you've been dreaming about. Our Web site provides history lovers with exclusive deals, advanced notification about new titles, e-mail alerts of author events, and much more.

MADE IN THE USA

Arcadia Publishing, the leading local history publisher in the United States, is committed to making history accessible and meaningful through publishing books that celebrate and preserve the heritage of America's people and places. Consistent with our mission to preserve history on a local level, this book was printed in South Carolina on American-made paper and manufactured entirely in the United States.

This book carries the accredited Forest Stewardship Council (FSC) label and is printed on 100 percent FSC-certified paper. Products carrying the FSC label are independently certified to assure consumers that they come from forests that are managed to meet the social, economic, and ecological needs of present and future generations.

FSC
Mixed Sources
Product group from well-managed forests and other controlled sources

Cert no. SW-COC-001530
www.fsc.org
© 1996 Forest Stewardship Council

Find Your Place in History.